drawing from the mind
painting from the heart

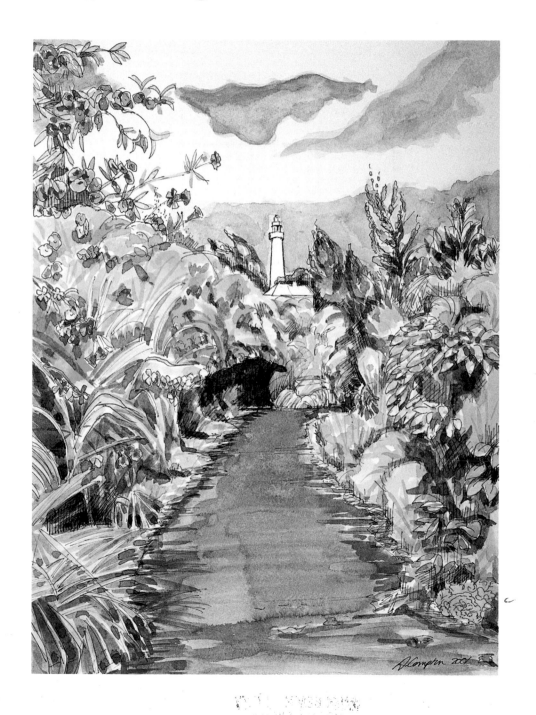

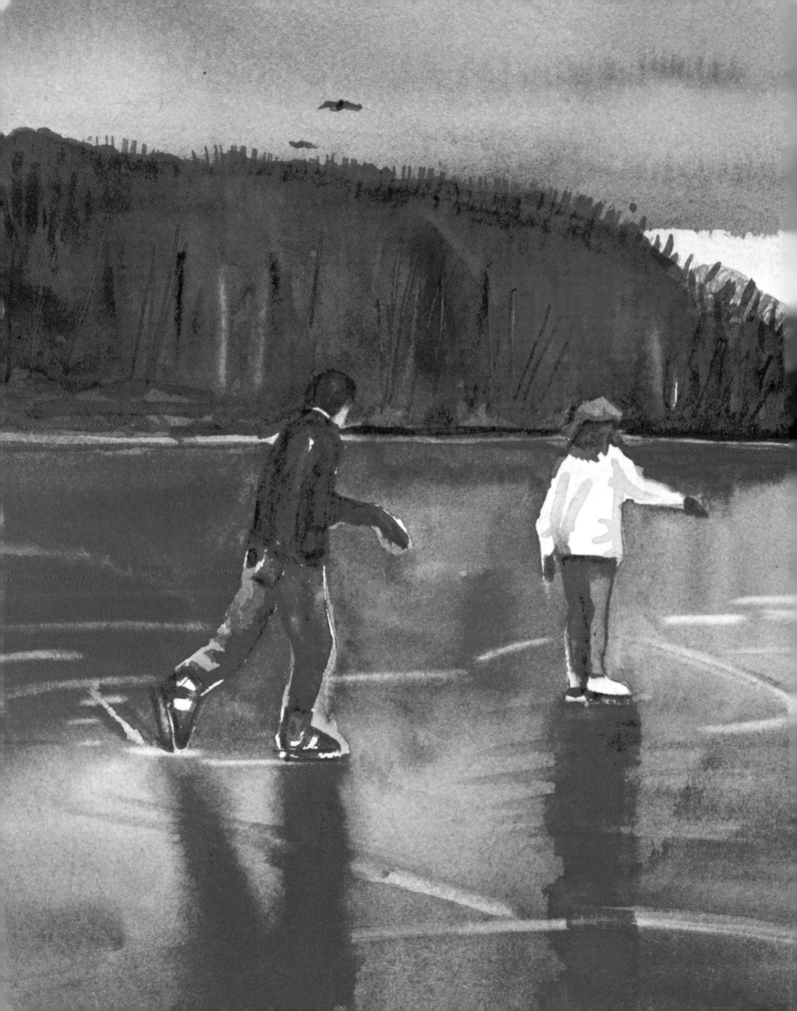

Annette Carroll Compton

drawing from the mind

painting from the heart

12 essential lessons to becoming a better artist

WATSON-GUPTILL PUBLICATIONS/NEW YORK

All artwork is by the author, unless otherwise identified.

FRONTISPIECE
LIGHTHOUSE IN BERMUDA
Watercolor on paper, 16 × 12" (41 × 31 cm).

TITLE SPREAD
SKATING ON EASTMAN LAKE
Watercolor on paper, 11½ × 18" (29 × 46 cm).

Senior Acquisitions Editor, Candace Raney
Edited by Robbie Capp
Designed by Areta Buk
Graphic Production by Hector Campbell
Text set in 10-pt. Berling

First published in 2002 in the United States by
Watson-Guptill Publications,
a division of
VNU Business Media, Inc.
770 Broadway, New York, NY 10003

Library of Congress Control Number: 2002106776.

ISBN 0-8230-1397-9

Manufactured in Malaysia

First printing, 2002

1 2 3 4 5 6 7 8 9 / 10 09 08 07 06 05 04 03 02

To those who sometimes doubt their ability to create,
but continue to believe in the limitless possibilities of Creation.

ACKNOWLEDGMENTS

I am grateful to join the talented array of Watson-Guptill artists, sharing what we love best to do: writing, painting, and teaching. Because one person in the warehouse was willing to listen to my rant about an out-of-print book, I was connected to Candace Raney. Her calm nurture and confidence in this project have led me to other talented people: editor Robbie Capp and designer Areta Buk.

Special thanks go to Sally Sherman, for her janitorial services, cleaning up my first draft; to Julie Ireland, for her generosity with her time, camera, and skilled, loving eye; and to Robert Seaman, for his patience, love, and confidence. Thanks are due to Gillian Nagler at the Currier Museum, Kris Walton at the Clark Art Institute, and Kathleen O'Malley at the Hood Museum. I am grateful to the students who prompt me to learn more, articulate better, and to hone my craft as a painter. Deepest thanks to my family, that through my creative mother and artistic father, I can be a useful conduit for the information in this book.

ABOUT THE AUTHOR

ANNETTE CARROLL COMPTON received her Bachelor of Arts degree in art history at Wheaton College in Massachusetts and her Master of Fine Arts degree in illustration from the School of Visual Arts in New York. She lives in Woodstock, Vermont, where she teaches and works as a commercial artist in her studio, Compton Art. Her frequent travels to teach workshops have taken her to Florida, Wyoming, Bermuda, Scotland, Guatemala, and France, and she is also active as president of the Vermont Watercolor Society. Her award-winning children's book *God's Paintbrush* is in its ninth printing.

PHOTOGRAPH BY JULIE IRELAND

contents

a visual world

Our world is one that barrages us with images. If you get a person to light on your image for more than three seconds, you are doing well. Images fire at us as we flick channels on a TV, as we ride the train, as we turn pages in a magazine. All are designed to distract us from what we are doing at the moment. "Hey, look at me!" scream advertisements all around us. Many of us spend most of our day in front of some kind of screen, reading words that are combined with images to heighten the experience. Yet, in addition to being receivers of images, all of us are creative image-makers by nature. We crave making marks, drawing, communicating nonverbally. But doing so is daunting in a world where images are so ubiquitous.

How did communication through images begin? Probably as a visual language, when speech across linguistic barriers was inefficient and drawing became a way of communicating. Directions were drawn with a stick in the sand, stones were stacked to indicate significant places, cave paintings seemed to be an inspiration to hunters and possibly to the spirits associated with the hunt. Much later, during the Renaissance, drawing was considered part of a basic education. Books were "illuminated," or made understandable by bright, colorful illustrations that enhanced the text for the nonreading or illiterate viewer.

Image-making today is often relegated to the "creative" ones. Many people claim, "Oh, I can't draw a thing. I'm absolutely not creative." But making marks has little to do with creativity. Actually, making marks is one of the most basic things a toddler can do. Assigning meaning to the marks makes it more complex. As we are being forced into a more visually assaulting culture, individually, we feel unsure of our own ability to make images. Ironically, at the same time that individuals become more visually mute, we have computers to increase our capacity to make visual images—if we only had the time or the images to make. We read magazines to generate creative ideas for our homes, where once we were confident of our family traditions or our own imaginations to create unique living spaces for ourselves. We hire designers, illustrators, interior consultants,

and organizers. Many of us feel we lack the time to be inspired. The pictures in our minds of what we wish to create may be holding us back. These mental images need to link to a process and a medium that inspires our hearts. If we relish the process of making art, we will transcend limiting objectives and be free to create our own personal work.

Artwork can become a celebration of personal process, a display of the artist's inner psychology, yet lacking in a universal connection. People sometimes go through a museum wondering how to identify with the concept. Artwork sometimes makes us feel stupid, like outsiders missing the point in a language to which we are not privy. Some artists seem to glorify how different, how avant-garde they can be; some are moved to being sexually explicit or to adding scatological material to increase shock value. With a barrage of horror-filled images in our culture, have we become so desensitized that we must keep pushing the envelope of our experience? Instead of stretching out to the cutting edge, we come to find that this proverbial edge is crowded with look-alikes making similar work. The answer is finding in our own hearts our personal connection to the marks we make as individuals.

But while we may have time, art supplies, and clean white paper, we are not always confident that we can express ourselves. Is it our technique? Is it what we are saying? Is it that we don't know ourselves well enough to trust the truth of what we produce? The trip from the head through the eyes and hand is a struggle. If we find our work unacceptable, we stop painting or drawing. We lose confidence or we continue to make that which is safe.

It is my hope that your journey through *Drawing from the Mind, Painting from the Heart* will be similar to walking with a sense of exploration, rather than destination. On any journey, if you keep turning left, you will eventually come back where you started, but you will have seen many things you would not have seen had you stayed put. I often walk this way in the morning. I take off in a direction, knowing that if I keep on, whether walking through woods or on a

rocky ocean coastline, I will eventually return to my home. At times in the walk, I wish I had chosen a shorter path or a well-known route to comfort me, but the scenery and smells encourage me. I always return revitalized and calm, having stretched myself outside the comfort of my known environment.

On your journey between heart and mind through drawing and watercolor, you may arrive at familiar destinations in your painting, and at other times, stretch yourself to your psychic limits. Leave your judgment and criticism at home. You know how pointless a hike would be if you stopped every few minutes to critique how your feet were hitting the trail—so relax, and explore the nooks and crannies of your artistic ability and notice how others have trod the path before you. Your critical self has no place on this journey. No matter how dangerous the route seems or how dire the results seem, be assured that if you got yourself there, you can get yourself out. Be patient with yourself. What is usually at stake is simply a piece of paper. Focus on the process, instead of the outcome, and you are bound to enjoy the journey—with the lessons ahead as your guide.

Annette Carroll Compton
MOOSE, WYOMING
Watercolor on paper,
12 × 16" (31 × 41 cm).

art from the mind and heart

Creating art involves a relationship between our minds and hearts. In this book, we're examining the question: Is that relationship balanced? For some, the mind plays a major role in our process as artists; you study technique and analyze your work intellectually. Technique can enhance the most intuitive expression. But what happens when you become so rigid in the dogma of your work that you lose your spontaneous expression?

Or are you drawn to abstraction? Do you lose yourself in expression to the exclusion of technique and become frustrated when you have trouble realizing your vision in your work? Where are you on these paths in your work? Your goal is to become more aware of your strengths as an artist and how you can become more balanced in your work, using both your mind and heart.

I see the creation of art as a continuum—an unbroken progression that draws on both mind and heart, line and form, representational and nonobjective expression. In this continuum, line implies an emphasis on the edges of the subject. Lines are marks made with a pointed medium: pencils, pens, and fine brushwork. Line work often requires fine motor control and careful training. Form, on the other hand, refers to the shapes of volume and color in a subject. It is easier to create form with a brush, though a series of lines placed together can also fill a shape successfully. Many people do not see form readily. Since the lines that separate forms often attract the eye first, line becomes the basis for all solid representational drawing. We will explore methods for creating line and form through pencil, pen, and brush; watercolor is the medium we use when working with brush.

Representational work is usually the preferred approach of beginning artists. As students increase in confidence, many achieve a highly realistic look. On the other hand, some begin to try varied expressions through line and form. These artists may work to achieve unrecognizable images that relate only to their emotions. Exploring representational work versus nonobjective work naturally leads us to the connection between the mind and heart. Throughout the exercises in this book, you will move between the mind and the heart to increase your ability to express yourself artistically.

All visual art falls somewhere on these continuums of mind-heart, line-form, representational-nonobjective. Most work is a mixture. For instance, the paintings of Josef Albers are highly intellectual exercises in color theory, falling near the mind end of the continuum, yet his shapes move close to nonobjective forms. A Sargent watercolor and a Cézanne watercolor fall in different combinations on the continuum as well.

For the beginner, it's important to study not only great art that you feel drawn to, but also to find the approach that you will enjoy most in creating your own work. How can you experiment with line and form to enhance your current work? Can you stretch yourself, reach farther in one direction or another to improve your capacity to express beauty and to make a lasting impression with your work? This book is designed to help you do just that.

TWELVE-LESSON COURSE

Divided into twelve lessons, this book is filled with exercises to stretch your technique and your expression, while exploring your relationship to the images you create in your mind and on your paper. The entire course is set up to encourage experimentation. As you progress through these pages, you will gain access to images you may not have examined before or known that you had deep within. More of your creative process will open as you tap into both drawing and watercolor, and through the process, get to know yourself better.

Drawing and painting are often taught separately. Yet, both disciplines are based on the tools of line, form, value, and color. The difference between making a line with pencil and making a line with a brush shifts us from line to form rather quickly. In trying to fill a form with the tiny lines of a brush or fine line of graphite, we have a different process at work. Artists usually approach each medium differently, based on these principles. There is no one correct way, yet, many artists become fixed in their method

of working, without trying new techniques. My aim is to help broaden your ability to explore drawing and painting simultaneously.

For me, my mind is a terrible foe when it comes to starting artwork. Suddenly, the laundry, the tea, the broom, the post office all seem far more important than putting something—anything, down. Get those paints wet! Just twenty minutes a day of nonverbal expression can do a world of good in opening your mind and allowing yourself to explore what is right for you, creatively. Don't worry about the outcome. Of course, for most of us, our critic comes along anyway, despite our best efforts. A solution to that problem is to form a painting group and do the exercises in this book with other artists. Rarely will anyone in a group of artists be as harsh with your work as you would be alone. No matter what your age or ability, you can enjoy improving your drawing and watercolor skills while connecting more to your mind and heart in your work. Let us begin!

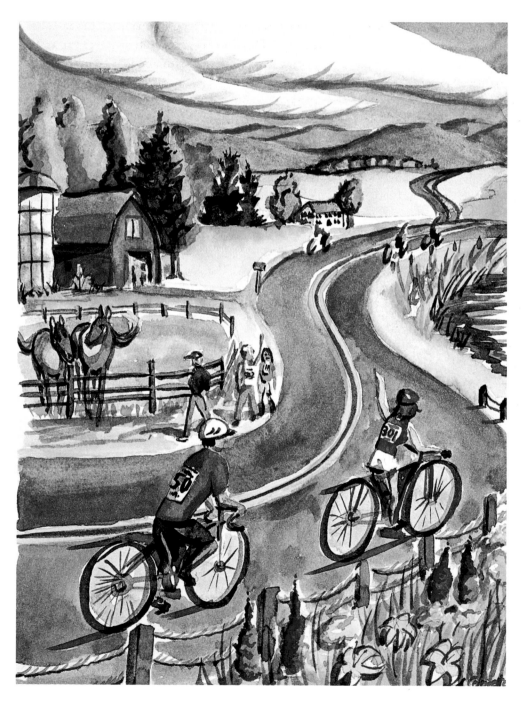

Annette Carroll Compton
**AUDREY PROUTY
BIKE RIDE**
Watercolor on paper,
12 × 7" (31 × 18 cm).

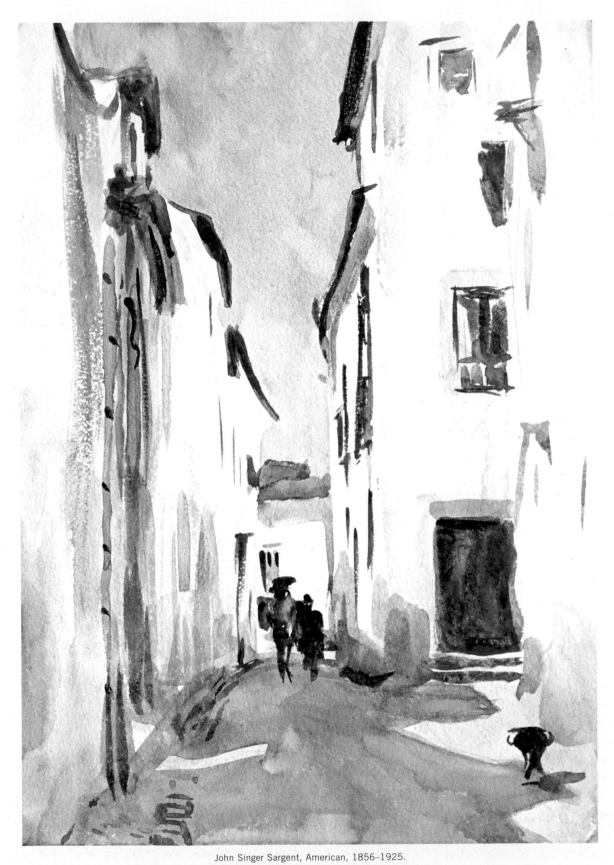

John Singer Sargent, American, 1856–1925.

STREET IN A MEDITERRANEAN TOWN

Brush and watercolor over pencil on paper, 14 × 9^{15}/$_{16}$ (36 × 25 cm).

Sterling and Francine Clark Art Institute, Williamstown, Massachusetts. 1955.1738

almighty edge

We will begin to explore line by drawing with pencil, pen, or brush. When drawing, notice how the line depicting edges separates the shapes of objects and the space that surrounds them. This is the most basic aspect of drawing. We use our mind for sighting and identifying the relation between the edges of objects. Are you enthralled by the flow of the line you are making? Notice how each drawing medium feels to you, and the differences among them. Play with a pencil, a pen, or a brush and ask yourself which tool makes a line that thrills you.

MATERIALS

The materials used in this lesson will be employed again in other parts of the book.

- 2B pencils
- 18"-x-14" pad of bristol paper
- kneaded eraser
- Sharpie fine-point pen or Itoya .05 or .01 marker
- #6 and #10 watercolor brushes, sable round
- watercolor paper, sheets or pad
- indigo or other tube of dark watercolor paint

ANYONE CAN DRAW

I am a firm believer that if you can hold a pencil or any instrument that makes a mark, you can be taught to draw. The difficulty lies in *what* we draw or how we depict something. Many of us become unsatisfied with our depiction of subjects and abandon drawing because we have concluded, erroneously, "I can't draw." What we might replace that statement with is, "I don't have the patience required for interpreting on paper what I am looking at." That is a very different statement from "I can't draw."

For most artists, seeing lines around shapes is the most obvious way to define separations between forms. The edges between the forms are the simplest way to break down a complex subject against a background. Let us explore how we create recognizable form through line drawing with pencil, pen, or brush.

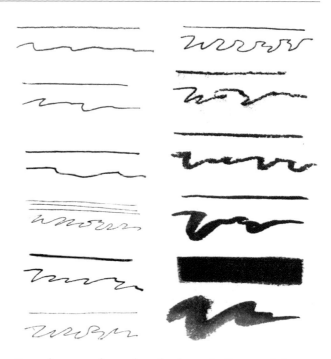

From the top, each set of marks shows the lines made by these tools: (left column) pencil, ballpoint pen, Sharpie pen, crow quill, mapping pen, .005 marker; (right column) .05 marker, charcoal, rigger brush, #6 kolinsky sable brush; the bottom two are a flat brush and a #10 kolinsky sable.

PHOTOGRAPH BY JULIE IRELAND

Experiment with many tools for making lines, to familiarize yourself with the varied range of effects that can be included in your drawings.

"out of mind" drawings

Draw the following images, using a pen: a house, a tree, a boat, a dog, a chair. Draw the pictures that come into your mind; don't draw from life or photo references at this point. Notice that in each of the preliminary drawings, you may tend to concentrate on the edges of objects. Your mind holds a silhouette of sorts, including details that help you create symbols. As you look at your drawing, you may be uncertain about their quality, because you have no actual reference to compare them against. Observation of subject matter will enhance your drawing skills greatly, and your confidence will grow through drawing often. Try not to judge your "out of mind" images harshly. What you have come up with is a reflection of how much information you have observed over time, not a reflection on your "talent." This is why "doodling" while doing another activity—especially while observing objects around you—can often be helpful to your drawing.

Now, draw with a brush from your memory. Use your best watercolor brush with some indigo paint on watercolor paper. This time, draw a cat, a pencil, a bottle, a flower, a bed. Does the pen line offer more control than the brush—or do you find the brush more lush? These are clues to your individual expression as an artist.

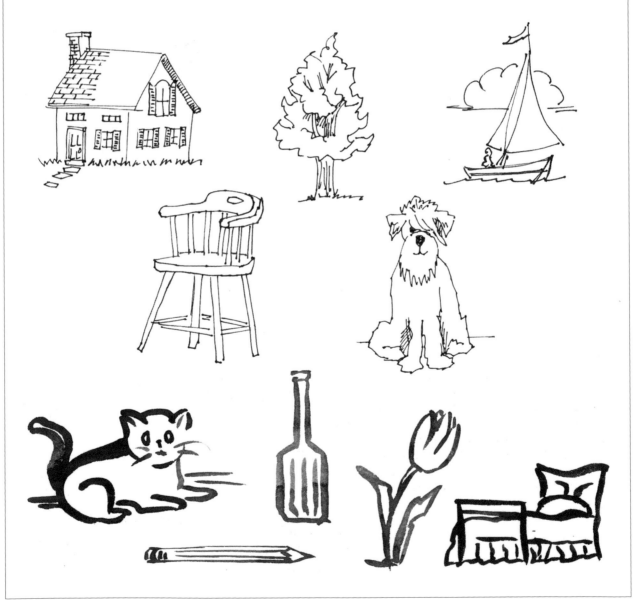

SIGHTING

When drawing, notice how the lines defining the edges separate both the interior shape of objects and the space around them. Can sighting and relational observations help you see the edges? Simply following the edge of the silhouette will not give you enough information for a three-dimensional form.

To move more toward such realistic work, it helps to scrutinize the things we wish to draw. We need to assess things like overlapping forms, where edges separate forms, and where lines curve, straighten, or angle. Over time, we need to begin to relate size and distance to one another, which we call the study of perspective. Many of these "mind oriented" tools can actually be understood through careful observation.

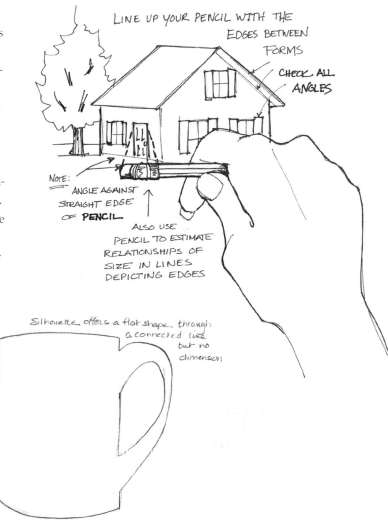

LINE UP YOUR PENCIL WITH THE EDGES BETWEEN FORMS

CHECK ALL ANGLES

NOTE: ANGLE AGAINST STRAIGHT EDGE OF PENCIL

ALSO USE PENCIL TO ESTIMATE RELATIONSHIPS OF SIZE IN LINES DEPICTING EDGES

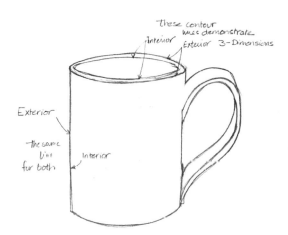

these contour lines demonstrate 3-Dimensions

Interior Exterior

Exterior

The same line for both Interior

Silhouette offers a flat shape through a connected line but no dimension

MIND EXERCISE

kitchen still life

Take a selection of things found in the kitchen and place them in an interesting arrangement. Consider their varying silhouettes: a Coke bottle, a pitcher, a wooden spoon, a whisk, a spatula, a tea kettle. Spend about twenty minutes doing a contour-line drawing in pencil on a smooth bristol paper. One simple contour line of the objects, without shading, is all you need to depict each object. Observe the places where things overlap. Notice how lines intersect, and where one edge stops and another begins.

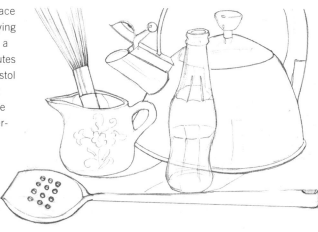

relationships

The trick is to be able to record what we see accurately for a more representational image. This is where judgment comes in. When I find myself being critical of my recordings, I remind myself not to be so invested in what I produce, but rather stimulated and excited by what I observe. Letting go of some of my exactitude offers a chance for expression in my line, for accidents to occur. Leaving marks that may be slips of the hand or producing ironic little marks to specify relationship of the objects offers the viewer a window into your thought process. Don't be shy about showing us your marks. Pentimenti—the evidence of erased lines—can show us the process of the artist. Observe the drawings of masters like Michelangelo or Leonardo. In them we witness the heart of the artist in the drawing. Accessing this part of us does not often come from exactitude and "getting it right." It comes from close observation of the objects.

HEART EXERCISE
blind contour-line drawing

This exercise is used in many drawing books, to access what we call the "right brain," or what I refer to as the heart of a drawing. Place a shell, a piece of wood, a crumpled autumn leaf, or other natural object in front of you. Put some music on and set your timer for ten minutes. Your eyes rest on the object rather than the paper. You draw the lines as you feel them, imagining your pencil to be a finger tracing the surface of the edge of your object. Let yourself look only at your object and enjoy its texture. Don't be too concerned about what is happening on your paper. The line you make is as nonconscious as the mark an EKG would make when recording heartbeats. Let your eyes inform the movement of your hand. Let anxiety go and enjoy the flow of your line. At the end of ten minutes, look at your drawing. It may look quite nonobjective, nothing at all like the object. Some would call it scribble. But the purpose of this exercise is to inform your mind about a particular object—not to make a perfect likeness of it, so don't be concerned about what you've produced.

Do one of these a day for a week as a warmup before painting or drawing. The trick is to stretch your willingness to participate even when you feel out of control, and to teach your eyes that the information you need for a good drawing is in the object, not on the page on which you are working.

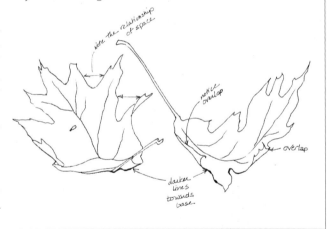

A crumpled autumn leaf, with its many angles, is challenging subject matter for creating a blind-contour drawing.

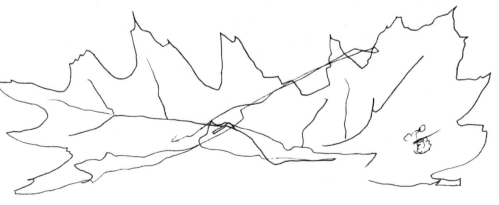

EVALUATE

Sometimes automatic drawing, like abstract expression, leaves us feeling out of control. We aren't sure we want to be Jackson Pollock. The work that comes up is rejected because it feels foreign to our eyes. We become critical of ourselves and we stop. We are not blocked creatives; we are creatives putting up blocks, because the flow of creativity is so overwhelming that we short-circuit. "There is nothing either good or bad, but thinking makes it so," said Hamlet. If we can enjoy the flow of ideas, root around in the closets of our minds, flesh out new ideas and make them visible, we will get more comfortable with our process, our images, and ourselves.

Evaluate how you feel after doing the drawing exercises in this lesson. If you were more comfortable with the first exercises, including the still life of kitchen utensils, rather than the second, decide where that puts you right now on the continuum between the mind and the heart. Look at what you've produced. Do you like your symbolic representations or do you like your automatic drawings? Many of us may have enjoyed the "mind" process more, but like the freedom of the result of the "heart" exercise. Neither one is "more right" than the other, but both support your own creative process.

LINEAR THOUGHT

Let's look at the origin of a line. Most of us born in the United States were educated to take certain concepts for granted—such as Point A goes to Point B, and other cause-and-effect basics. The world still revolves around Newton's comfortable theory that when the apple falls from the tree, gravity sends it to the ground. The only problem with that absolute is that it has been eclipsed by Einstein and others discovering the theory of quantum mechanics and chaos. While there is a divine order to chaos, it is sometimes hard to discern.

What has this to do with drawing? The origin and ending points of lines can make a beautiful tracery of chaotic dots. The lines are so necessary to make sense of these points where things begin or end, connect and intersect. The "connect-the-dots" exercise ahead will help explore both the mind and heart in your observation. When you do the exercise, your sighting points may be off, or you may have to concentrate profoundly to keep your proportions accurate. Either way, this exercise offers another tool to help you render subjects accurately. Don't judge your drawing for its accomplishment; applaud yourself for observing closely and recording what you see.

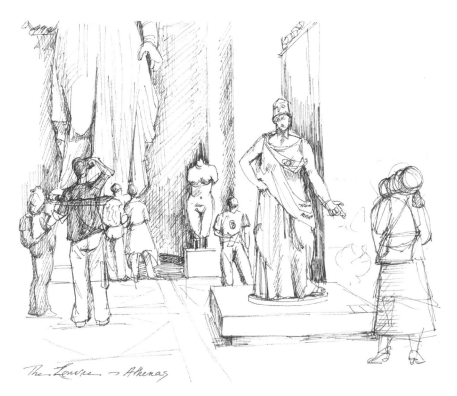

Annette Carroll Compton
**THE ATHENA ROOM
AT THE LOUVRE**
Ink on paper, 8 × 10½"
(20 × 26 cm).

First I drew the statues, then as an afterthought, added the people who were photographing them. By not preconceiving an outcome, I allowed myself the freedom of spontaneity in recording this moment at the Louvre.

As artists, we are anxious to "do it right," "get better at it," or maybe "make more work that is salable." Yet, we are rarely comfortable taking a long, circuitous, expressive path to shake up our work, trouble our souls, and confront habits we have developed in years of working. Or as beginners, we are unsure of where to start—so we just don't start.

Most inexperienced artists are intrigued by something they wish to record visually. I spoke with a woman who went on excitedly for ten minutes, describing the image of fresh snow falling early in late autumn on golden grass. She told me that was the only reason she wanted to learn to paint: to be able to depict that image. I asked her what was stopping her. "I don't know how," she replied.

Well, none of us knows exactly how to take something that is basically three-dimensional and put it on a two-dimensional surface. The concept of painting or drawing is a complete abstraction of reality, no matter

how realistically we are able to depict it. Even a photograph is removed from the actual experience. But we can try to use tools, including observation, to achieve an illusion of reality.

What is exciting is the thought that is filtered through the mind and the heart of the artist. Coupled with your ability or techniques you have learned, indeed you may be able to produce an accurate representation of what you want to convey. The road to being a better artist is to access both the mind and the heart for each problem as it arises. In the past, you may not have been open to the heart part because it wasn't exercised in a logic-based school system. Or perhaps now, your mind will be stimulated more—the part that may have been fallow during all the expressive art classes you took, where splashing more than painting was the norm. Either way, now you are being challenged to try new things.

connect the dots

Place five or six paper bags under a light. Observe where lines from the edge of one bag are perpendicular to another or where a line begins or ends. Think of those points as "dots." Your job is to observe only those "dots"—the intersections and to record them on the paper, rather than the trajectory of the line in between the intersections. Your paper may begin to look like a

series of hash marks, rather than a "drawing of something." Your ability to perceive relationships is challenged, as is your ability to record accurate distances and proportion. Record every edge you can see and challenge yourself to record the general composition relative to the edges of the paper. Now, begin to "connect the dots" to see if you can create a linear drawing of the paper bags.

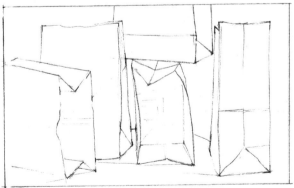

making marks

How frustrating it can be to make marks with a brush when we are looking for the control afforded by the fine line of a pen or pencil. Some people love the expression found in the thick/thin lines, the soft flow of color, or the variation in value. Others prefer the control of the line with a harder material like graphite or pen. A brush moves us closer to form, while the pen keeps us looking at the "almighty edge," unless we become more comfortable with our marks.

The desire to make a mark is ancient. It seems that many species communicate through marking. My dog walks with me every day before we go to the studio. He continues to "mark" on trees outside the post office after sniffing around for several minutes to sense what other dog has been there before. I retrieve my mail, I read it, I look through the catalogs and colorful junk mail, and he checks the tree. We are both receiving communications through marks.

I remember the endless loopy scribble I would write as a child, thinking I was making words that everyone would understand. My grandmother would read out loud to me from my voluminous pages of writing, and I would delight at three or so that she could make sense of my marks. Granted, she let her imagination go, and so I let mine go, scribbling more, to see what she would say next. Her encouragement kept me "writing." Soon, I would draw. Sometimes I told her what my images were; at other times, she saw something even more beautiful than the one I imagined. I was encouraged to communicate through line.

Not everyone is fortunate to be nurtured this way. One of my students said, after exploring a mark-making exercise, "I've taken back my barn! When you asked us to go back in time to a place where we drew, I remembered drawing our barn in great detail.

I painted it brown, and my mother told me it was wrong because our barn was red. I never had the confidence to draw again."

Sometimes our mark-making is edited or corrected by an overprotective parent or critical teacher. Their instinct may come from a desire to improve our work or come from their own frustration at their own limited visual vocabulary, but it scars us. Making marks becomes an unpleasant experience to be avoided. "I have no talent," becomes our mantra.

By nine or ten years old, the symbols we once used, such as almond shapes for eyes, become inadequate. Our brains have become split into two distinct hemispheres by this age, and we notice that which used to satisfy us viscerally leaves us feeling inadequate. The left brain begins to judge that which the right brain has been happily spitting out in automatic drawings. I remember distinctly a day in fifth grade when Lisa, one of my drawing friends, drew a girl with beautiful deep-set eyes, with lids and lashes and everything! The drawing was beautiful, I thought. So realistic! I was still drawing almond shapes for eyes. I saw what she had done and rather than saying, "How did you do that?" I said, "Why can't I do that?" I began the mantra that followed me to graduate school: "I can't draw that well."

Going back to a nonverbal place is a challenge for most of us. Our intelligence has been measured by multiple-choice tests and true/false answers. These linear routes to evaluating knowledge are easier to assess. Teachers burdened with large classes require shortcuts for measuring success, yet many students excel in ways not revealed by standard tests. Thinking in a straight line usually appears to be the simplest route. Let's use that thought to explore line.

musical lines

Wet your brush and put a large amount of paint on your palette. Dry your brush by blotting, then fill it with slighty moist color. Put on some music, preferably an instrumental piece, about twenty minutes long. Meditate on the music; begin to feel its rhythm. Now respond to the music with lines or marks. Try to vary your line with the music. If you need a finer mark, dry your brush more. For a darker mark, use more pigment and less water. Let yourself express the feeling of the sound through the marks you make. When the music stops, examine your work with a curious mind. Is the feeling of the sound conveyed?

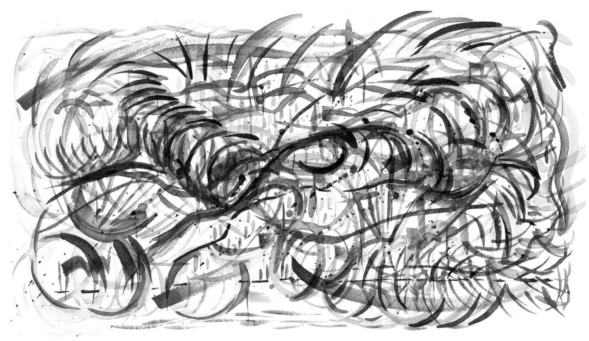

Annette Carroll Compton
PAINTING TO CLASSICAL GUITAR MUSIC
Watercolor on paper, 10 × 18" (25 × 46 cm).

line drawing or form?
your personal signature

What makes watercolor stand out is its unique ability to conform to the will of any given painter. In other words, it is a "signature medium," one in which no two people will make the mark exactly the same way. However, many watercolorists resist the natural mark they create, scumbling or fussing with their brushstrokes. Some have a heavy hand with pigments, others a light, layered technique. The trick is to accept one's marks and to become more comfortable with making them.

One woman who studied with me had never painted before. She produced thick, colorful, flat paintings, full of energy in the color, yet stability in the form. Another person who had never worked in watercolor, but had been an experienced oil painter, was thrilled to discover the expression in her brushstroke. The watercolor revealed each stroke so individually that her whole painting style changed to one with many linear marks. It added confidence to her stroke and allowed her to see a new way of looking at her subjects and her work. Expressing yourself confidently is always an element of deeply moving artwork.

Line is the first place we see the hand of the artist: the actual mark, the stroke on the paper. One of the many benefits of taking workshops is that you can learn from the other participants. Try the next exercises with a painting partner. Observing other artists opens one's mind to the possibilities of expression. For study and practice, I applaud the study of other painters' brushstrokes by copying some of the masters. This is the way most great painters learned how to take what they liked and leave the rest. I am not suggesting that you duplicate an artist's work to "pass it off" as your own, but rather to command fluency with your brush or pen or maybe simply to gain a deeper respect for the individuality of another artist.

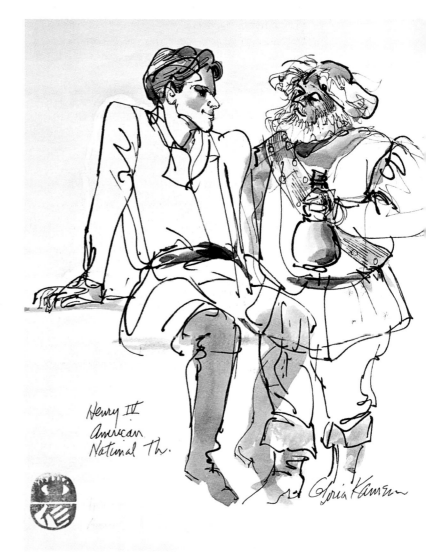

Gloria Kamen
HENRY IV
Ink and watercolor on paper,
9 × 11½" (23 × 30 cm).

With a sketch pad in her lap, this artist works dress rehearsals at major theaters, capturing the body language of actors with her rapid, fluid, and evocative line, as personal as her signature.

painting with a partner

Choose a piece of music that is at least ten minutes long, and join with a partner. Have a large sheet between you; use your brush and/or pen to dialogue nonverbally between you. As the music begins, listen for a minute, then begin by making a line with your chosen medium; your partner then responds to your mark by making a second. Resist the attempt to "read" the images as you go; rather, let the music move you and guide your mark-making more than the other person's mark—but be sure to integrate the marks each of you is making into one piece. You may each want to try the other's style at some point during the painting.

The student paintings shown, painted in teams of two, were created to the music of various composers. These are the kinds of dialogues we want to have with ourselves as we create a painting. Dynamic tension in line, form, and color offer unique images for us to confront.

portrait partnering

Try observation with a brush. One of you will pose while the other paints. With the brush, begin to record your representation of the face in front of you, in line only. Let accident and expressions occur, without judgment, only observation. Notice how the pressure on your brush can achieve a varying line weight affecting the emotional meaning of the line.

Lisa Theurer
PORTRAIT
Watercolor on paper, 8 × 10" (20 × 25 cm).

This is the first-time drawing with a brush for this student. It is natural to rely on edges to create the form of the head, just as you would with a pencil, yet the line produced is often thicker.

lesson 1 studies

MIND WORK Research five of the artists listed here. Try to copy at least one drawing or painting from each artist. With whom do you identify most? Does making line with a brush intrigue you more, or do you prefer to have the supporting line of the drawing in your work first? Which medium resonates with you?

HEART WORK Get up earlier than usual, and spend no more than twenty minutes recording dreams, drawing an object, or simply "doodling" with line only. Or if you are inclined, take a morning walk and record one image in line during the walk. Explore your medium—either ink, pencil, chalk, or brush.

MIND-HEART WORK Set up a simple still life of fruit. Do a contour-line drawing, using watercolors. Enjoy the process of "coloring" the subject.

GREAT ARTISTS TO EXPLORE

WHO USE LINE IN EXCEPTIONAL WAYS

Peiter Brueghel

Raoul Dufy

Oskar Kokoshka

Berthe Morisot

Pablo Picasso

Jackson Pollock

John Singer Sargent

Egon Schiele

Clyfford Still

Henri de Toulouse-Lautrec

Cy Twombly

Andrew Wyeth

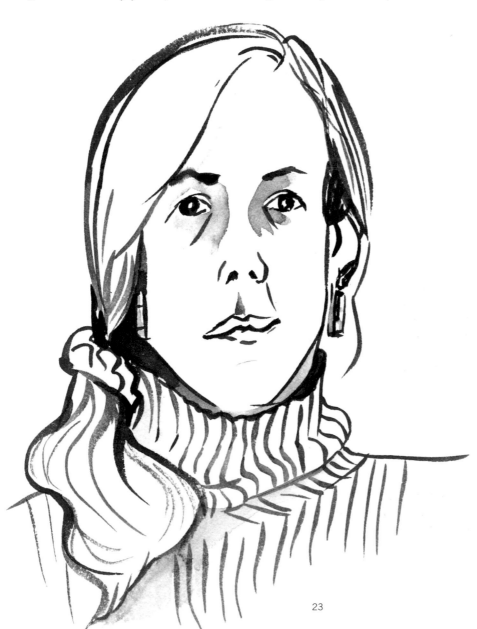

Annette Carroll Compton
SELF-PORTRAIT
Watercolor on paper,
12 × 16" (31 × 41 cm).

This is not part of a partner exercise—it's my own self-portrait—but it, too, demonstrated how the use of simple lines with a brush can portray basic forms.

23

Anders Leonard Zorn, Swedish, 1860–1920
UNE PREMIÈRE
Watercolor and brown chalk over pencil on paper, 13 × 10¹⁄₄" (33 × 26 cm).
Sterling and Francine Clark Art Institute, Williamstown, Massachusetts. 1955.1922

within the edges

After working with contour lines in Lesson 1, you have surely noticed that a connected line becomes a shape, or form. We call it form when we can differentiate the interior from the exterior of the shape with line. It may appear to be a solid if we fill it in, creating a flat shape with color; think of Early American silhouettes, created by shadows from a light source. But if we have a light source on the object and observe it, rather than its shadow, we begin to see the three dimensions of the object. This three-dimensional quality can be recorded through line if we understand how line can produce something called *value*—the relationship between the light tones and dark shades in a drawing or painting.

HATCHING, CROSSHATCHING

Lights and darks can be beautifully rendered with line, using a time-honored technique called *hatching*. It requires patience and motor control to place multiple parallel lines next to one another to achieve a variety of values. Crossing these hatched lines with a series perpendicular to them is called *crosshatching*. Both techniques can improve your handling of a brush or pen. The fact that you repeat the strokes over and over strengthens the muscular control in your hand—an important asset for the artist. In this lesson, we will see how hatching and crosshatching can build form and how these techniques can be applied with brush-strokes to produce interesting painted effects.

Depicting volume through lights, darks, and cross-hatching in order to turn line into form is a life-long pursuit for representational artists. As we explore the shapes of volumes and how to describe them, we move away from the security of the edge. This may require us to use our minds more than our hearts, but the structure we build will have a strong foundation of realism, offering a comfortable place to explore the freedom of the brush within the confines of the lines.

five-tone value scale

Draw a five-tone value scale in pencil, using crosshatching; then draw one in pen and ink; then one in drybrush with watercolor. Which feels more manageable? How can you apply each to your work? Your mind will be interested in the intellectual aspect of getting the value right, or of recording an accurate representation of the object. Your heart will enjoy the process of putting down lines adjacent to one another. Your heart will enjoy building up the form, but your mind will like the result. Since the process of building up form with hatching may be slow, your mind may be impatient. Try to still your mind, trust the process, and enjoy creating value.

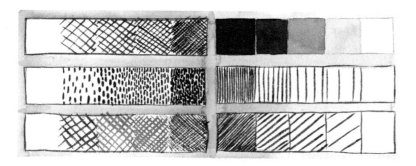

In these value scales, note that the value varies with the proximity of lines next to one another; the closer they are, the darker the value; the farther apart, the lighter. Value also varies according to the pressure you put on your pencil or pen or the amount of water and pigment you use.

traveling inward, observing value

For many novice artists, the edge is the most obvious place to start when drawing. Others are more struck by the solid object, the volume of the form. Nuances within that form become visible to us when illuminated, but with subdued light, we see little of the three dimensions of the form.

Some people perceive value acutely, although they may have difficulty reproducing it. Others see large, flat shapes of color—value is secondary and must be a learned thing to observe. But value is the key to depicting objects realistically. Without value, we have to rely only on the edge of objects and their shapes to give us a three-dimensional quality. The exercises that follow offer ways to make seeing and depicting the value of a form easier.

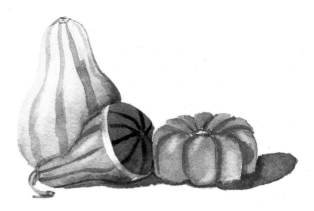

Nature's lines on gourds are superb examples of lines that trace the trajectory of the object's third dimension. I refer to these as "cross-contour" lines. Since most subjects we depict don't offer such built-in help, the artist can construct imaginary cross-contour lines to help define volume in objects depicted.

MIND-HEART EXERCISE

drawing with crosshatches

Set up a still life of garden tools, such as those in the example shown. Shine a light on them from one direction so that you can easily see the light and dark values. With a graphite pencil, draw the objects, guided by a "wireframe,"—a pale, cross-contour grid that helps establish the height, width, and depth of the objects; in other words, their volume. Now erase your grid, and proceed to crosshatch with pencil or pen to build form, as in the second example. Build the drawing up slowly, leaving white space, adding the next darker value, then the next, and so forth, until you accentuate the darkest darks with your heaviest crosshatching, as seen in the final drawing.

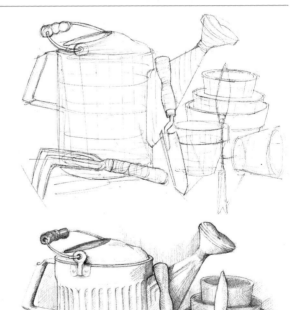

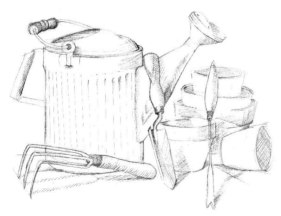

learning to see form

As a little girl, I was desperate to become a better artist. My father was the family artist, with strong opinions of how things should look. I would say he drew with his mind. His heart was in the process, but often his mind overtook his heart with judgment. It eventually stopped him from making any work of his own. But before that happened, I was fortunate to be his student.

One of the first exercises he gave me involved a book that was filled with black-and-white illustrations of famous musicians. He told me to trace an image a day, following the lines and contours of each portrait, like a topographical map. I was fascinated. At age seven, I began to see the world expanded from edges into hills and valleys of form. That exercise kept me busy for nearly a year, working diligently at tracing portraits of Beethoven, Mozart, Bach, and other greats.

Later, during my teen years, when I aspired to be a fashion designer, I used *Vogue* magazine for my drawing exercises. But the neck or the wrist of the models I copied always looked flat to my eyes. My father rescued me again: "The neck, the wrists, any limb of the body is a cylinder. Imagine putting a ribbon around the cylinder. If you look down at the cylinder, the line appears to be a smile of sorts. If you look up, it's a turned-down smile."

Still later, when I took the life-drawing classes at the School of Visual Arts in New York, our instructor taught the same principle when it came to musculature: contour lines that weren't obvious had to be imagined. It became a game for me, and it improved my drawing. My mind was completely immersed in the activity.

But where did my heart live in all this? The study of line, contours, and cross-contours entertained my mind, training me to observe more accurately, but my heart became frustrated by such tedious analysis. Yet, I enjoyed the quiet repetition of creating value through hatching; building up a form that way did engage my heart. So in the last analysis, choosing subject matter and lighting becomes an exercise for the heart.

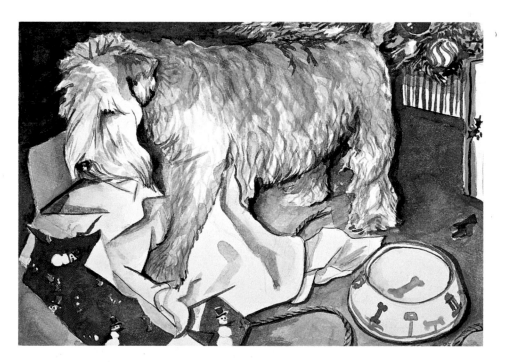

Annette Carroll Compton
HOWARD'S PRESENT
Watercolor on paper,
8 × 13" (20 × 33 cm).

They say, "Write what you know." Well, paint what you love. My dog Howard's wavy coat provides natural cross-contour, and watching him open his present stirs my heart, making it an easy image to paint.

wire-frame studies

Begin with simple shapes, such as my examples: a hat or a muffin and doughnut. There is still the "almighty edge" describing the outside of these forms. Yet, you can also imagine creating the lines that follow the circumference of the forms—their "cross contours." Drawing a "wire-frame" construction will help you determine volume. This is a very mind-oriented approach to creating the volume of a still life, but it helps us see three dimensions, which can then be translated into watercolor studies of the objects, as shown for the hat and doughnut/muffin.

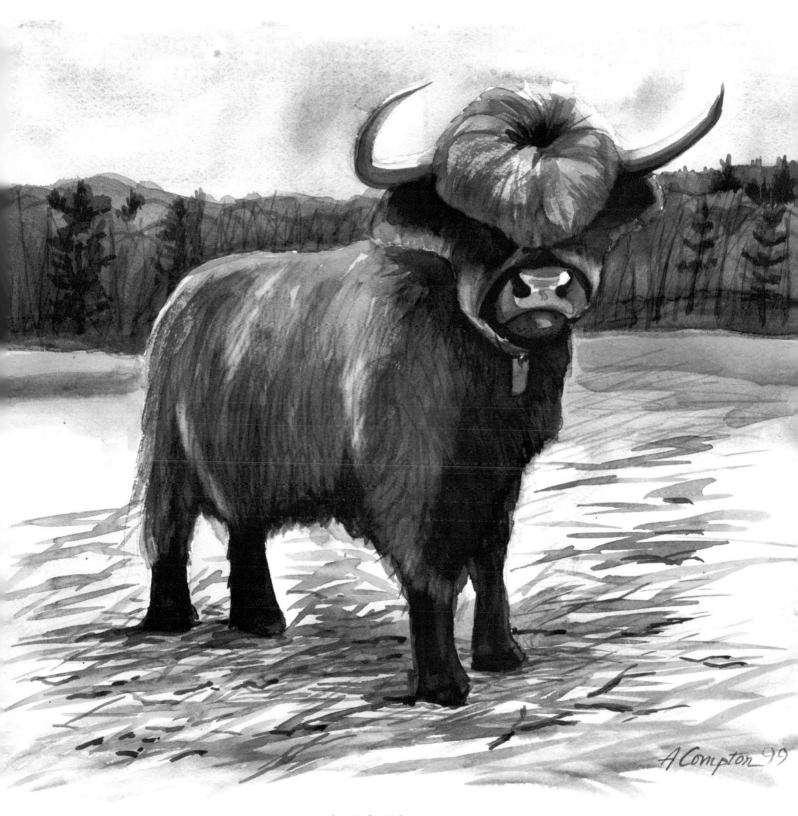

Annette Carroll Compton
THE HIGHLANDER
Watercolor on paper, 18 × 16" (46 × 41 cm).

Here, I used linear brushstrokes to build up the animal's form. Contoured strokes follow the direction of the doughnutlike crown—the steer's "poof" was windblown into that shape—an oddity that drew me to this subject.

value strokes

Rule a quarter sheet (5½" × 8½") of watercolor paper into four quadrants. With a brush and indigo paint, create patterns within each quadrant by using various lengths of lines and brushstrokes. Notice that the wider the marks are from each other, the more they provide a light value; lines that are closer together provide a darker value. Use your heart to choose which values (light, medium light, dark, medium dark, or black) appear in each space. Observe what happens when you put a variety of values next to each other; you can create a sense of space just through the progression of grays. Also note how darks tend to advance and lights tend to recede. The exception is white space. In my example, the white triangles seem to leap off the page.

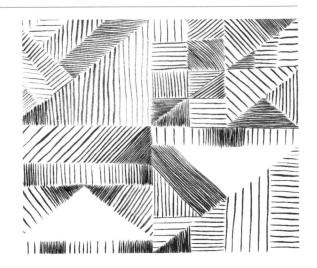

cross-contour brushstrokes

Let's apply the cross-contour concept to still-life painting, using our wire-frame model as a guide. But refrain from drawing first. Paint spontaneously. To activate your heart, choose colors that describe your still life to you. On a blank sheet of watercolor paper, begin to paint, ignoring the "almighty edge" until the end. Start with the objects' interiors; paint a series of cross-contours that traverse the horizontal axis of each object in your still life, then paint perpendicular strokes to follow their vertical axes. Build up brushstrokes that follow the natural contours of each object. Use expressive, bold strokes, no matter how foreign it seems. Resist relying on the edge of the forms in the hope of maintaining "control."

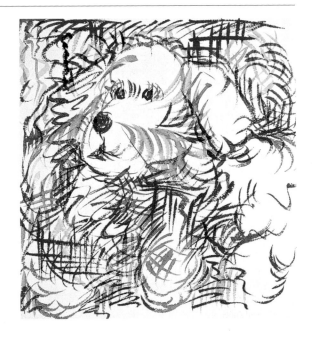

crosshatch partner painting

This exercise is particularly enjoyable when done with a painting partner. Sharing the working experience opens your heart and turns down your mind. Set up a still-life arrangement, then tack a full sheet (22 × 30") of watercolor paper on a support board, placed on your easel. Start with lighter watercolor tones first, applying crosshatching strokes with your #10 sable brush. Fill the values and colors of the objects. Alternate with your partner. Add hatching in a color and value you think appropriate, then let your partner add to it; the paper surface is large enough. Consider the cross-contours of the objects along with the "almighty edges." See if you can both use your brushes directionally in an expressive way. Notice as you apply your paint that it runs together if it touches, creating a solid form of color. Suddenly the lines are gone. Work athletically, using large gestures as you stand at the easel. Enjoy the space you have to create, to splash, to play. Do not concern yourselves with producing the "right" kind of painting.

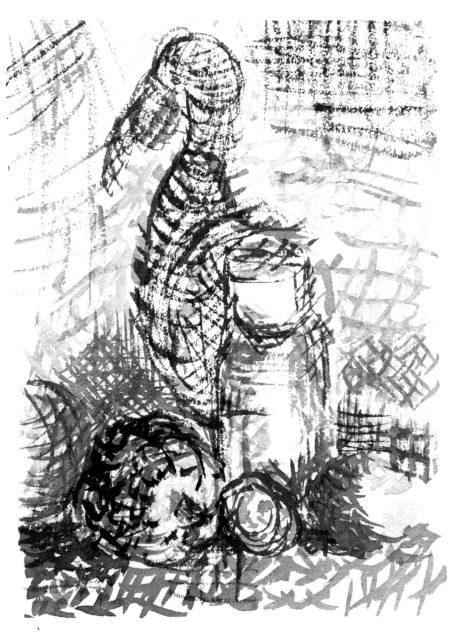

Robert Weidlein and
Mary Young
**CROSSHATCHED
STILL LIFE**
Watercolor on paper,
16 × 12" (41 × 31 cm).

lesson 2 studies

GREAT
ARTISTS
TO EXPLORE

**WHO USE
LINE AND
CROSSHATCHING
IN EXCEPTIONAL
WAYS**

Pieter Breughel

Paul Cadmus

Honoré Daumier

Albrecht Dürer

Francisco Goya

Reginald Marsh

Michelangelo

Andrew Wyeth

Anders Zorn

MIND WORK In your sketchbook, for one week, do a page a day of practice with crosshatching. Get up earlier than usual and spend no more than twenty minutes on this mind work. Try creating one five-tone value scale every morning in a different medium: pencil the first day, pen the second, charcoal the third, small brush the fourth, large brush the next. Discover the challenges that arise with each medium. This exercise improves brush control and fine motor skills necessary in tight, realistic work. It also improves confidence with your mark-making.

HEART WORK Find examples of etchings, drawings, or paintings that appeal to you, created through crosshatched lines. Retain them in a clipping file or scrapbook for inspiration and future reference.

MIND-HEART WORK Set up a still life of five things that describe you as a person. Make it a narrative still life about you—items that represent your talents, interests, hobbies, or other aspects of your life. Describe the items through crosshatching, either in pencil, pen, or paint.

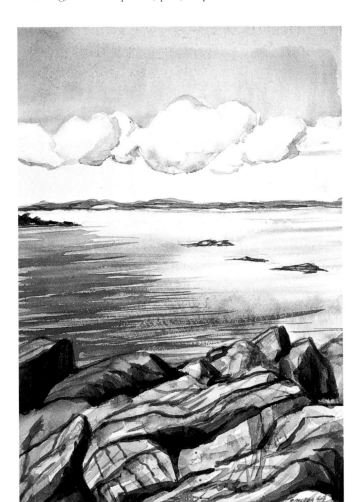

Annette Carroll Compton
SCOTTISH WATERS
Watercolor on paper,
16 × 12" (41 × 31 cm).

Mastering the technique of hatching can help depict textures like water or forms like rocks. Often we need to go beyond the edge to convey form through cross-contour lines.

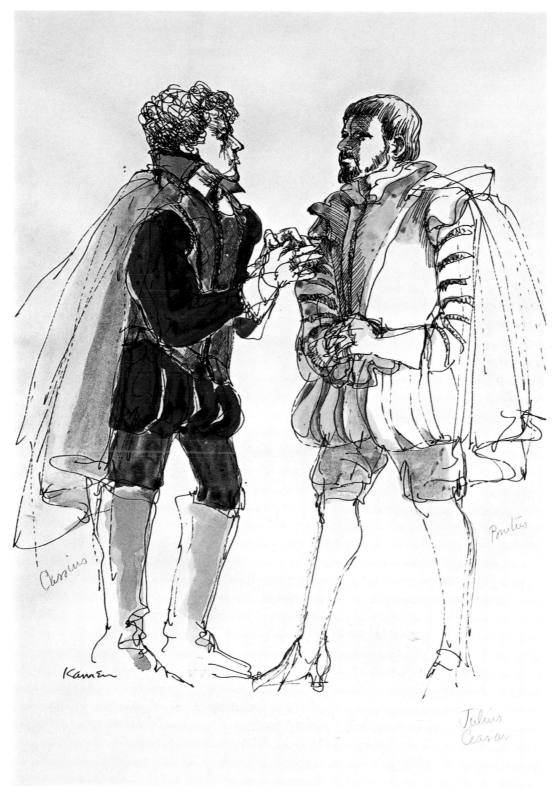

Gloria Kamen
JULIUS CAESAR
Watercolor on paper, 16 × 12" (41 × 31 cm).

When working under time pressure recording a theatrical event, using line to express the cross-contour of a form encourages us to comprehend a "quick sketch." The form is further defined by using a brush to apply color.

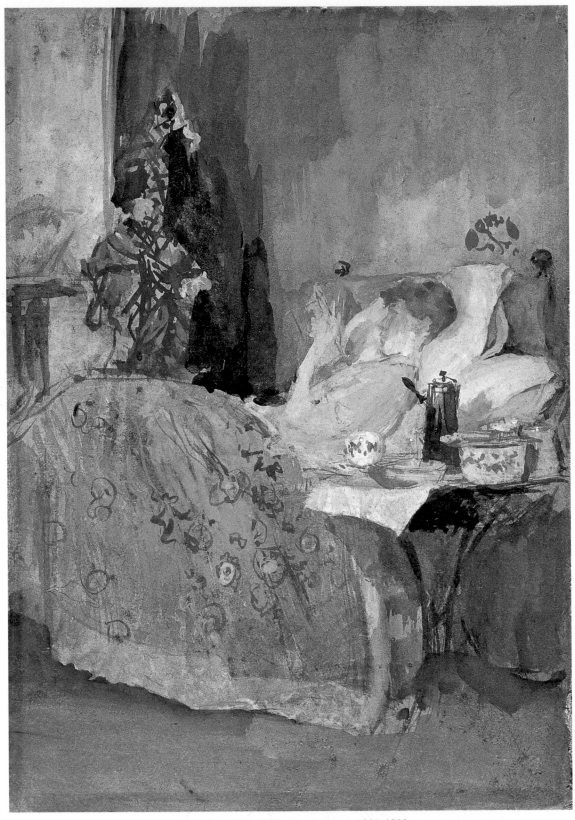

James Abbott McNeill Whistler, American, 1834–1903
MAUD READING IN BED, 1883–1884
Graphite, pen, brown ink, and watercolor on tan board, 9⅞ × 7" (25 × 18 cm). W.971.26
Hood Museum of Art, Dartmouth College, Hanover, New Hampshire;
gift of Mr. and Mrs. Arthur E. Allen, Jr., Class of 1932.

shaping the interiors

As you explore form, you naturally begin to look at shapes. Much of your work as a watercolorist involves designing a variety of shapes in a pleasing way. Value begins to clarify distance and create volume, but the flatness of the shapes can also make an interesting composition for viewers to enjoy.

This lesson focuses on the "big picture"—composition—and learning to look at the shapes that it comprises. The edge provides the boundary line for the form, and in watercolor, water can separate one shape from another. We'll explore how watercolor technique can help you create interesting, simplified shapes.

SIMPLIFYING FORM

Where some artists are drawn to the combination of line and the outside edge of the subjects, others are drawn to volume—the shapes next to one another in a composition. If you start with a line, bend it until it touches itself, you have a shape—a circle perhaps. Add changes to the line and you have a different shape. We can categorize most shapes into two families: angular shapes and amorphous shapes. Angular shapes are those with sharp, linear edges; amorphous shapes are those with curves and irregularities. Both can be interesting and beautiful. Both can remind us of silhouettes of natural or man-made objects of all sorts.

As painters, it's important for us to observe shape, because that's what our marks make when we use a brush: shapes. With a pencil, our initial marks are linear; we must consciously fill in an area, either by crosshatching or blending with graphite, to make a solid. With a brush and watercolor, we can fill an area of color simply by allowing the pigment to float into a wet area on the page. A line, with a brush, is a more thoughtful act. We must consider the point of the brush, the amount of water and pigment, and the lightness of our touch to achieve a clean, even line. The pencil and the brush balance each other along the continuum of line versus form.

go with the flow

You may feel frustrated by your perceived lack of control when it comes to watercolor. Many potential students tell me, "Oh, watercolor is so difficult—I can't make it do what I want it to do." What that means to me is that the person has not experienced the joy of allowing color to puddle into a wet area, to tip it back and forth on the board, letting it flow and fill spaces as it will. This is the unique attribute of watercolor, making it quite different from oil or acrylic in most applications—which was first demonstrated to me when I was quite young.

I have fond memories of a childhood trip to Washington, D.C., for spring school break when I was about nine years old. My love of art, and especially watercolor, had already been nurtured by my father. How I loved watching him mix and puddle his watercolors. But he rendered his work tightly, using only small brushes that were slightly dry. He put color on with an immense amount of control. So, finding an artist under the cherry blossoms, on this sunny day in Washington, piqued my curiosity. I went over and

asked her if I might watch. She was happy to have me there, but went on with her painting, paying little attention to me. I watched her lay in a great puddle of water on her paper, which was attached to a board on an easel. As she dropped various pale greens into the water, I saw her snatch the board off the easel and begin an aerobic dance, tipping her board one way and then the other. There was no brush involved, other than for her initial application of color. She let the water and pigment work with gravity to spread fabulous hues across her page. It looked to me like magic. I was enthralled.

I soon understood that the edge of the wetness is what stopped the pigment from traveling to another area on the paper. The artist controls the color's movement by controling how much water is put on the paper, and where it's put. The line separating wet from dry on the paper creates a shape. That is the key to keeping watercolor under control. Try it, and discover for yourself the beauty of the shapes you make that sit next to each other to create your watercolor painting. Let's explore the possibilities in the following exercise.

still life of shapes

Being a quilter, I love this exercise. Toss a favorite quilt over a rack, and set up several simple shapes in front of it—such as a vase, box, and pitcher. On a sheet of watercolor paper taped to a board, make a contour-line drawing, recording the shapes rather than the form of each object. Break down the shapes of color in the background quilt and study how they interact with the objects, incorporating the quilt pattern with the objects through a maze of line. This is a good exercise to help you integrate background with foreground in any artwork.

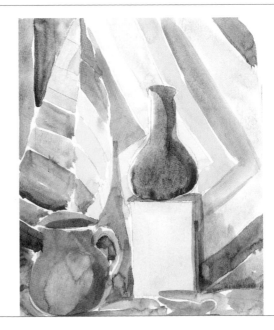

Annette Carroll Compton
QUILT STILL LIFE
Watercolor on paper,
12 × 9" (31 × 23 cm).

shaping the edge

Tape a sheet of watercolor paper to a board. Paint a shape, using a clean brush and water—no paint. While the water is settling into the paper, mix up your favorite color. Load your brush and place some paint on the wet area. Tip and tilt your paper so that the pigment disperses evenly. Add another color. See how they comingle to produce interesting effects. It is also important to be aware of how colors could run into each other if one wet shape touches another. Avoid that by working on a shape that is removed from the one you have just completed.

In my "shape-to-shape" example of houses and trees, each was painted separately in this way. To practice in the studio, set up a still life of interesting shapes and paint them using this wet-in-wet technique.

PHOTOGRAPH BY JULIE IRELAND

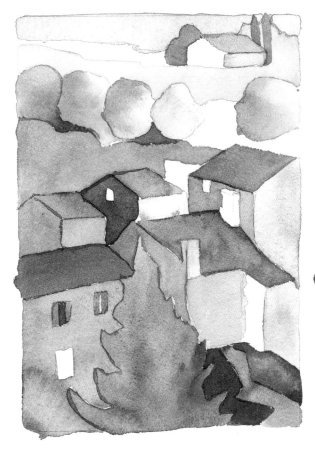

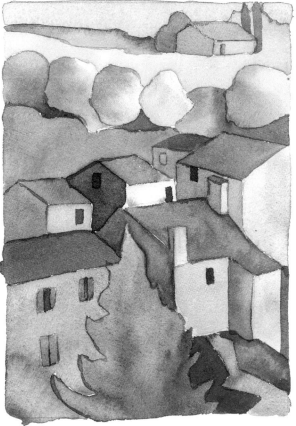

Annette Carroll Compton
PROVENCE
Watercolor on paper, 12 × 8" (31 × 20 cm).

water shapes

On a sheet of watercolor paper, paint a shape and fill it with color. Now, imagine a number between one and nine, to be placed on another spot on the paper—but instead of painting that number, paint the "negative space" around it with water. Then drop color in the water, leaving the number as the white paper surrounded by the negative space you've just painted. Look at the difference between filling a shape with color and filling negative space with color—how the white number comes forward with color painted around it. This painting of negative space is a mind challenge. Enjoy the shift you experience when you're not painting an object, but the space around or between objects. Do it again, with a different color and a different number. Respond to the images you've created and try to link them with different colors. Observe the strength and dominance of the white shape. Consider how you might apply this to a painting.

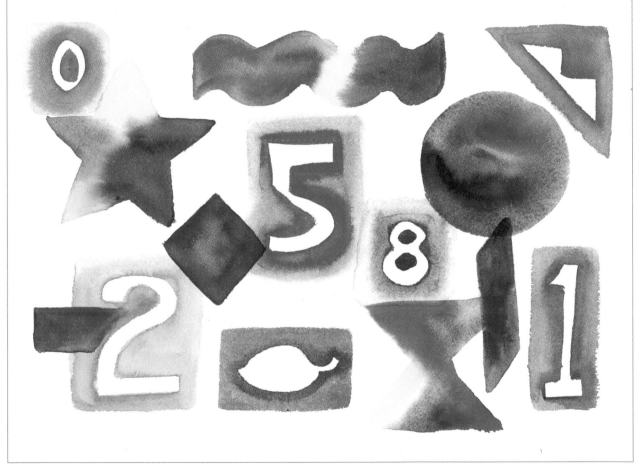

water shapes with regained edge by drawing

Set up a simple still life: flowers in a vase, with pieces of fruit in front. Flow water only onto your paper in the total shape of the still life. The "almighty edge" does not have to be created with a pencil; the water stops the edge of color, creating a solid form in the shape of the objects.

Now drop paint in to depict the different colors of your still life. Let them flow together to the edges of the water. Allow yourself to experience the overall composition of the objects against the solid white of the background.

Now take a second piece of watercolor paper and wet the whole sheet. Drop the shapes of color onto the wet paper. Enjoy how the colors mix and play with one another on the paper. Let the painting dry thoroughly. Now go back with a pencil or a pen and draw on the colors. Remind your viewer of the "almighty edge." Add crosshatching and let the big shapes of color underneath inform your drawing on top. This is an excellent process to get you comfortable with the flow of watercolor, as opposed to the childhood idea many of us retain about "coloring inside the lines," from years of using coloring books.

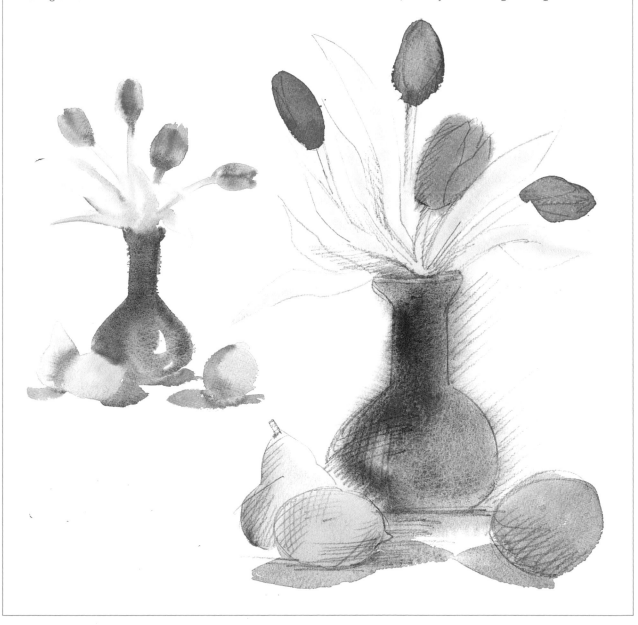

working with charcoal

To see the progression from line to form with another medium, let's experiment with charcoal. Take a sheet from your sketchbook and a stick of willow charcoal, one of the oldest and easily accessible mark-making tools, around since people heated with wood or coal. Make a mark on the page. How does it feel? Most people enjoy the buttery flow of the charcoal after the precise scratch of a pencil. Write your signature, as you would on a check, and you'll see how challenging it is to get a sharp, clean line. Make a larger signature and run your thumb over it. As it smudges, see how much lighter it becomes. All kinds of marks can be made by smearing charcoal. This shift from line to form is also easily made when you use the tip or the side of the stick. Try crosshatching some boxes in a five-tone value scale and see what happens when you smudge the lines together to collect them into one value. Now practice making a shape with the side of the charcoal.

smudging

Draw an object with an interesting silhouette, such as a candlestick or a simple cylinder, like a flashlight. Using the side of the charcoal, rather than the tip to form edges, draw the shape of the object. Try another object and see how it differs as you vary your marks. Feel the flair of the marks you make to fill in the silhouettes. Enjoy the softness of the charcoal. There is no need to set lines to fill in; simply make shapes out of the whole side of the charcoal.

line versus form

Set up four blocks of different shapes to see how the planes interact with one another. First, do a charcoal, contour-line drawing of the blocks. Notice how the charcoal makes a line and how accurate you can be with this soft medium. Then draw the block shapes by using only the side of your charcoal. Create values from light to dark to suggest three dimensions. Avoid making lines or focusing on edges; enjoy the shapes only. Which drawing was easier—looking at edges or looking at shapes? Knowing your preference can guide your direction as an artist.

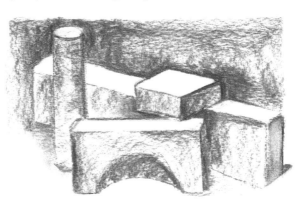

sculpting

Take some Play-doh or clay and sculpt a small amorphous shape. Place this shape amid the blocks and begin to draw with the side of your charcoal. Notice that the line of the shape is different from the edges of the geometric block forms. As you use the side of your charcoal, notice which is easier to depict. Are you more willing to forgo detail and accuracy in drawing the amorphous shape because it takes more effort to record that information? Knowing how you respond to geometric versus amorphous shapes can be helpful to you in selecting subject matter for your drawings and paintings.

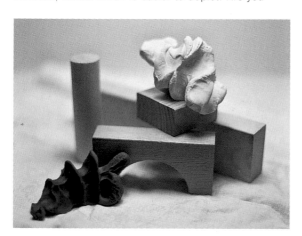

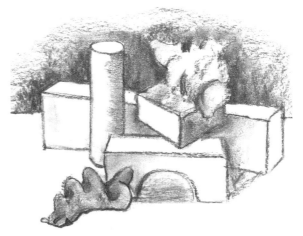

setting your stage

When you compose a painting, you treat the four sides of your paper as if it were a stage on which actors are positioned to engage the audience's attention. Which "actors" in your subject do you want your viewers to see first? Which colors stand out the most? Is your eye always drawn to the largest item—or does texture from multiple brushstrokes distract you?

A theater director considers the overall action on the stage and provides a balance between the players and the spaces around them to create dramatic tension. Likewise, when composing a painting or drawing, determine how objects or shapes move on a two-dimensional plane. When deciding how to distribute value, consider that darks tend to advance and lights tend to recede. However, as I noted earlier, the one exception to this rule is profound when it comes to watercolor: White shapes advance over darks and lights—a principle that is emphasized in the next exercise.

MIND-HEART EXERCISE

winter landscape

Let's create a landscape painting of snow from real life or from a photo. First, do a charcoal sketch to explore values. The winter landscape is an extreme of shapes and values in most cases; only on cloudy days are you able to enjoy the subtleties of the midtone grays. Now for your watercolor painting, compose the white space in a way that makes the entrance to the painting inviting, but also clear in terms of distance. Remember that painting less in watercolor is often painting more. Let your heart guide you.

Next, I mix permanent rose with cobalt blue to make the violet. The many vibrant neutrals are blends of quinacridone burnt orange, gold, and indigo. My darks come from the three transparent staining paints: quinacridone gold, permanent alizarin, and phthalocyanine blue.

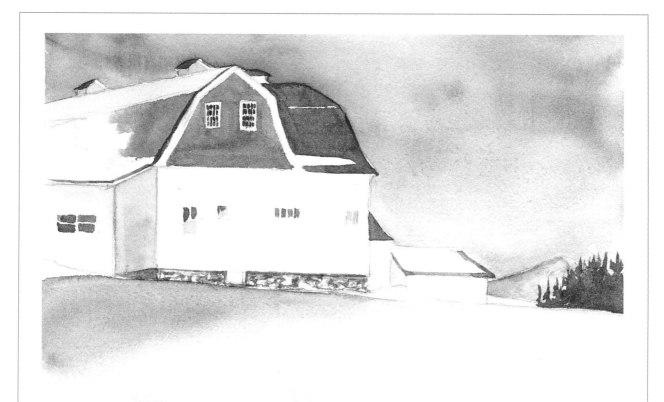

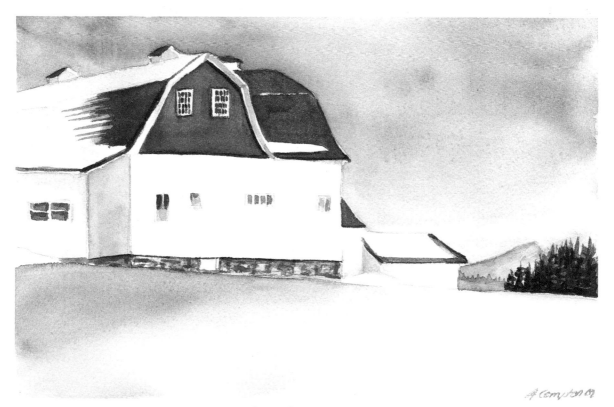

Annette Carroll Compton
WINTER SCENE
Watercolor on paper, 7 × 12" (18 × 31 cm).

43

lesson 3 studies

GREAT ARTISTS TO EXPLORE

WHO USE SHAPE IN EXCEPTIONAL WAYS

Alexander Calder

Paul Cézanne

Stuart Davis

Robert Delaunay

Jasper Johns

Jacob Lawrence

Fernand Léger

Henri Matisse

Juan Miró

Piet Mondrian

Maurice Prendergast

James Abbott McNeill Whistler

MIND WORK Choose one of the artists listed here and create a painting or drawing of your own in the style of that artist.

HEART WORK With Play-doh or another clay product, each morning for a week, make a three-dimensional shape of your choice. Save all seven shapes for subjects to use in future work.

MIND-HEART WORK Create a drawing, collage, or painting that includes some of the three-dimensional shapes you have constructed with your clay.

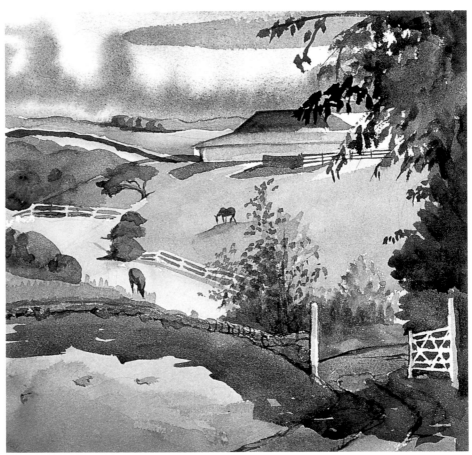

Annette Carroll Compton
AT BARNY
Watercolor on paper, 12 × 12" (31 × 31 cm).

Here, doing a shape painting can help reduce a complex landscape to a series of forms.

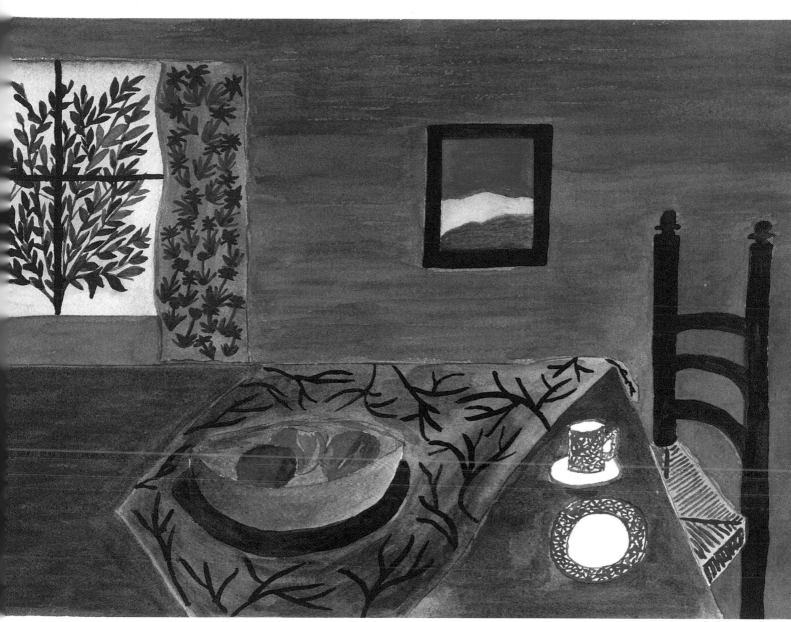

Judy Laliberte
INTERIOR STUDY
Watercolor on paper, 12 × 16" (31 × 41cm).

This bright interior was painted by a student as a "Mind Work" study, inspired by the art of Henri Matisse.

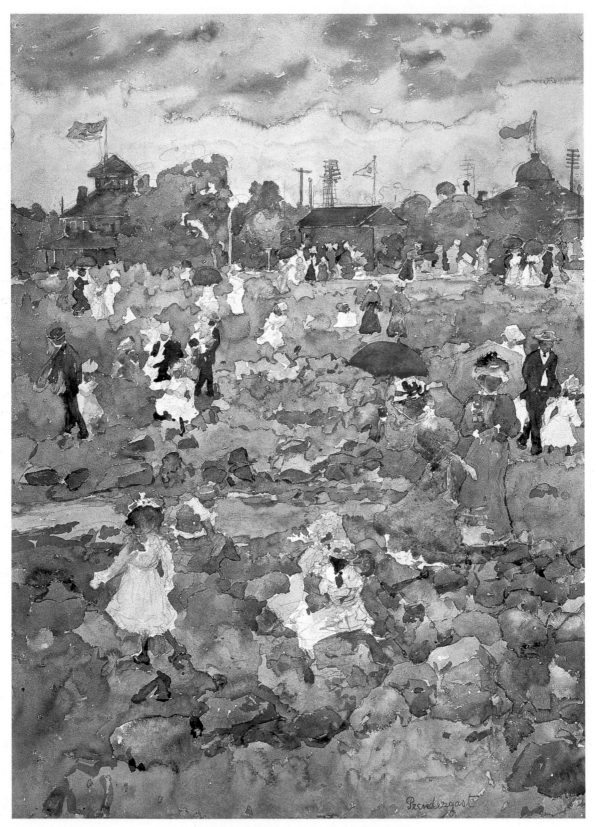

Maurice Brazil Prendergast, American, 1859–1924
THE STONY PASTURE, c. 1896–1897
Watercolor and graphite on paper, 19³/₈ × 13⁷/₈" (49 × 36 cm).
The Currier Gallery of Art, Manchester, New Hampshire.
Museum Purchase: George A. Leighton and Mabel Putney Folsom Funds, 1959.6.

the intellect of color

As you fill shapes with paint, you are seduced by the joy of color. But color choices in a painting can create everything from beauty to horror. This lesson will help you to understand the basics of color theory and how the specific properties of watercolor pigments affect your choices. Your left brain, fascinated by order, enjoys the precision of color mixing, while your heart thrills to the experience of a full palette with myriad choices. Exercises in shape help you control the complexity of color. As you learn to mix colors, your paintings become more complex and interesting.

WHAT IS COLOR?

So often I hear students say, "I want to paint because I love color." I have never heard anyone say, "I want to paint because I love black and white so much." Perhaps that choice would be expressed by a photographer or a draftsman, but rarely a painter. We artists are usually drawn to the complexity of color. So knowing something about color theory is another tool for the watercolorist.

In the 1600s, Isaac Newton discovered that when light shines through a prism, colors appear, separated into their component parts in the familiar rainbow spectrum. Color is therefore relative and dependent on light. In a dark room, color does not exist. The actual color of anything is relative to the light shining on it.

Our color knowledge is relatively brief when looking at art history as a whole. Color theory as we know it today has only been studied since 1839, when the French chemist and dye master Michel-Eugène Chevreul published his findings, which were to become the scientifc foundation of Impressionist painting. But the range of pigments available to nineteenth-century painters has expanded considerably, and today, we have myriad colors from which to choose—a mind-boggling array that can be categorized as to stability, irridescence, brightness, and hue. Without clear information, it is easy to rely solely on the heart, choosing colors to which we feel drawn, while overlooking useful colors for our palette. So let's explore some basic properties of watercolor pigment, through the exercises that follow.

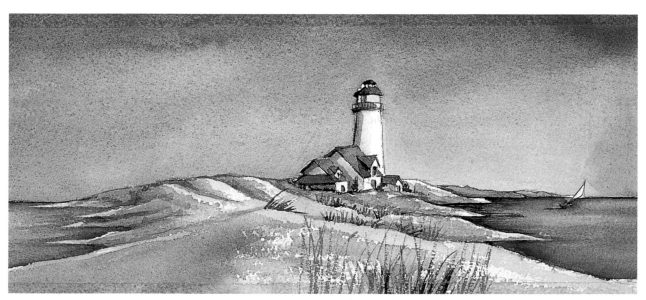

Annette Carroll Compton
CAPE COD LIGHTHOUSE
Watercolor on paper, 7 × 15" (18 × 38 cm).

favorite colors

Select your ten favorite watercolor pigments and put a dab of each on your palette. Tape down a quarter sheet of watercolor paper. With a pencil, draw a line that overlaps and intersects, creating a random web of shapes over the whole sheet. This is your "subject." Put on music that you enjoy, and begin painting the web with colors chosen from your heart. Tip and tilt your board to fill spaces, rather than fussing too much with a brush. Work on balancing the ratio of pigment to water to get a variety of tints. Leave a few spaces white for balance. As you complete your painting, study which colors advance and which recede, and how colors work next to each other. Do some colors fight each other?

uncertain colors

On a second sheet of paper, create another random web of shapes. This time, select ten colors that you dislike, for whatever reason. Maybe the colors are too bright? Too opaque? Too dull? Maybe you are irritated by how the pigments mix or cover? As you paint the shapes, notice your reaction. Is it harder to complete this painting? Stick with it. Sometimes letting your heart run the show can actually change your mind about things. Open your mind to the possibility that these colors could be useful to you.

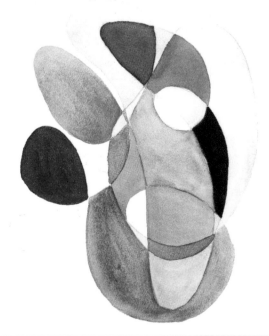

the unique properties of watercolors

Painting with your heart can be done with any medium, be it oil, acrylic, or gouache. However, watercolors provide a unique opportunity to explore the pigments themselves. Each pigment is finely ground and mixed with gum arabic, which acts as a binder. When water is added, the pigment flows. Because of varying organic properties (colors based on vegetable or animal matter) or inorganic properties (mineral-based colors), watercolors present an added challenge, in that each paint may act differently when applied to paper.

Watercolor pigments are characterized in terms of their properties and characteristics. There are five different types:

- LIFTABLE colors are clear, delicate, often organic, and can be removed.

- SEDIMENTARY pigments are very bright and thick, often inorganic, and usually leave color sediment on the paper's surface.
- STAINING colors are clear and dark, often inorganic, and may stain brushes and palettes as well as paper fibers.
- OPAQUE paints are thick, allowing little or no light to penetrate their pigment. They may have a base of white, and the colors are often light in value.
- EARTH colors are exactly that: dirt from different regions. Often they are heated and earn the title "burnt," adding richness to their hue.

In every pigment category, watercolor can be a medium of mind or heart, but using your mind to think through and plan a painting can make for beautiful, clear, luminous art.

MIND EXERCISE
rainbow fence

Draw a long line, about a half-inch thick, in black indelible marker across a sheet of watercolor paper. With a #10 round brush, paint a "fence" of your colors across the sheet. Start with the yellows and progress through the color spectrum, painting long stripes of color over the black line. Study the colors to see which ones cover the line opaquely and which reveal it, though very subtly in some cases. This demonstrates the sedimentary or opaque colors verses the transparent or staining. Once the paints are dry, with your brush, loosen the lower part of the "fence" with clean water, and blot each stripe with a paper towel. You will find that some paints are removable and some stay there for good.

This exercise is best done with professional-grade watercolors, since their pigment-to-binder ratio tends to be higher than that of student-grade paints, which often combine transparent, sedimentary, and staining properties. I suggest that you buy the best paints you can afford, right from the start of your watercolor experience. Your work will be richer for it.

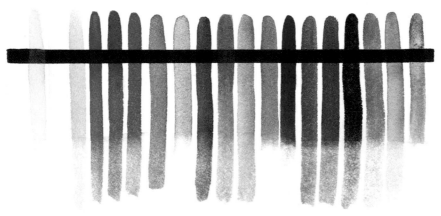

primary triads

Applying basic color theory is one of the ultimate mind exercises when painting. Many of us know all about mixing the three primary colors (red, yellow, blue) to make various shades of secondaries (green violet, orange) and tertiaries (a mixture of two of the three secondaries). But when we are painting, we may suddenly be overwhelmed by what we see in our palette, and forget the color principles that should be referred to in making artistic choices.

HEART EXERCISE

color circle

Choose three primary colors that you like: one yellow, one red, one blue. Make a color circle and mix the secondary and tertiary colors to see how they combine. From your heart, choose a second triad of primaries (that is, a different yellow, red, and blue) that might create subtle grayed tones in the secondaries and tertiaries. For your third circle, choose your brightest, most vivid triad to mix. In my example, observe the differences, particularly in the secondary colors. The violets tend to become brown if the red is too orange or the blue too green. A pure orange is challenging if the red and yellow are both too brownish, or desaturated, to start with. Understanding color theory can help your heart make informed decisions.

MIND EXERCISE

color triangles

Make color triangles with these mixtures, and notice how different the pigments seem to be. *Left to right:* LIFTABLE: aureolin, rose madder genuine, cobalt blue; SEDIMENTARY: cadmium yellow, cadmium red, French ultramarine; STAINING: quinacridone gold, permanent alizarin, thalo blue; EARTH: raw sienna, burnt sienna, Payne's gray; OPAQUE: Naples yellow, Indian red, cerulean blue; PRINTER'S PALETTE: cadmium lemon, permanent rose, peacock blue. Notice how different the secondary mixtures are in each of these six triads. Consider the advantages to having a mixture of saturated and desaturated colors on your palette. While our hearts may prefer one or the other, a range of colors can help us more accurately express light and value.

layering color

Watercolor also offers the added appeal of being able to look like layered sheets of stained glass. The technique is known as *glazing*—layering washes of watercolor, one on top of the other. Both wet-on-wet and wet-on-dry layering are useful techniques for the watercolorist to master. You may mix these techniques in a painting to achieve balance.

Annette Carroll Compton
FRUITS
Watercolor on paper,
7 × 12" (18 × 31 cm).

RIGHT: *These simple fruits are painted in their local (natural) colors, against a mixed background. For the pear, I used quinacridone gold and burnt orange; for the apple, permanent alizarin with a stripe of aureolin and permanent sap green; for the lime, permanent sap green and cobalt.*

BELOW RIGHT: *In this version, for the pear, I applied aureolin first, then cobalt blue. When intermixed on the wet paper, the two colors became green. Then I added alizarin—a red complement to green (the color opposite it on the color wheel). It became too brownish, so I returned to the pear's local color, yellow-gold—quickly adding some sedimentary cadmium yellow pale to overpower the other colors, which achieved my objective. For the apple, I followed its cross-contour lines in applying layers of paint: aureolin, cobalt blue, permanent rose, and a heavier cadmium red. The lime, being light green, is a middle-value color. I started with yellow, added blue, then red, and finally, permanent sap green. To bring back the highlight, I accented with cadmium yellow pale.*

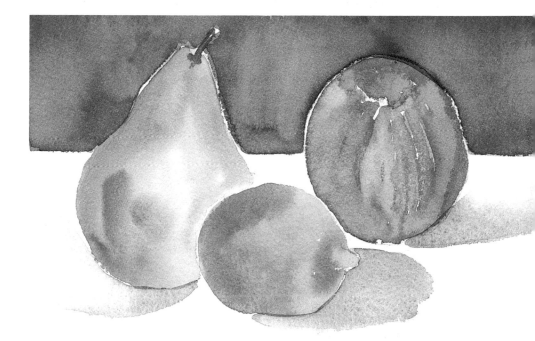

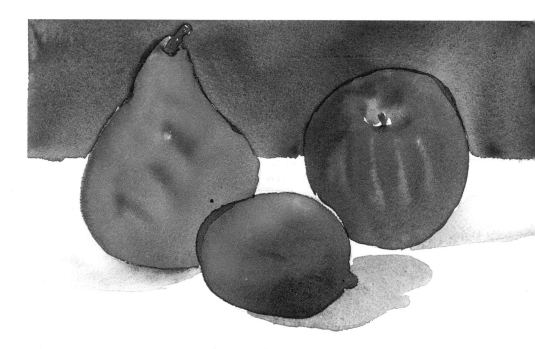

wet-on-dry glazing

Divide a quarter sheet of watercolor paper into quadrants, on which you will layer one color over another. Following my example, for your initital wet-on-dry washes, apply colors such as these: upper left, aureolin (transparent yellow); upper right, rose madder genuine; lower left, quinacridone gold; lower right, cobalt blue.

After the first layer has dried, add rose madder about two-thirds up the first quadrant; let it dry, then add a final glaze of cobalt blue over a third of it. Repeat this exercise in the second quadrant: over the rose madder, add colors such as cobalt violet, ultramarine, sap green. At bottom left, over the gold glaze with green, blue, alizarin, violet. In the final quadrant, over the cobalt blue, I've added French ultramarine, Winsor blue, permanent rose, royal blue, and Winsor emerald. Note that I increased the number of glazes with each quadrant. Try doing the

same—going from three colors to four, five, and finally, six. You might want to punctuate these imaginary landscapes by drawing details on top of the layered glazes.

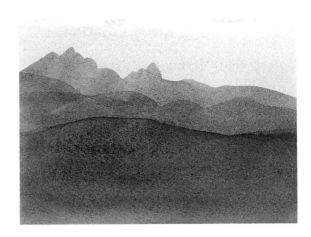

WORKING WITH TRIADS

Working with triads can build confidence, while simplifying your palette to only three colors. To get a variety of value, the trick is to balance the water/pigment ratio, and also accommodate your blends to the benefits and shortcomings of different pigments. My four studies are examples of the different effects achieved with triads of staining colors, printer's colors, earth colors, and opaque colors.

STAINING COLORS *Working with quinacridone gold, permanent alizarin, and Winsor blue produces a lovely range of values—both clear, luminous lights and deep, rich darks. Because of their intensity and saturation, the pure colors impart an aura of sunny light.*

PRINTER'S COLORS *Cadmium lemon, permanent rose, and peacock blue produce a brightness characteristic of these intense, saturated colors, close the spectrum of printer's inks—yellow, magenta, and cyan.*

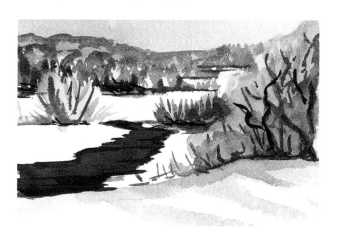

EARTH COLORS *In this winter scene done in raw sienna, burnt sienna, and Payne's gray, the sunny brilliance is achieved by concentrating on value, since these desaturated colors are inherently muted, which lowers their luminosity.*

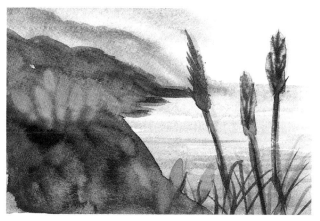

OPAQUE COLORS *Naples yellow, Indian red, and cerulean blue have basically light values, so pure darks were not achievable in depicting these pampas grasses at Big Sur. But the copious sediment in these heavy paints provided a lovely mist, using a wet-on-wet technique.*

Annette Carroll Compton
TRIAD LANDSCAPES
Watercolor on paper, each 5 × 6¹/₂" (13 × 17 cm).

lesson 4 studies

MIND WORK Each day for a week, paint one small painting (about 4" × 6") with a different triad of colors. Mix them together in triangles, as we did earlier in this lesson, to see what happens when these colors join.

HEART WORK Choose three primary colors and two additional secondary tube colors (green, orange, violet) and create a painting. Allow the *color* to be the subject, rather than an object. Notice how a color is affected by another adjacent to it.

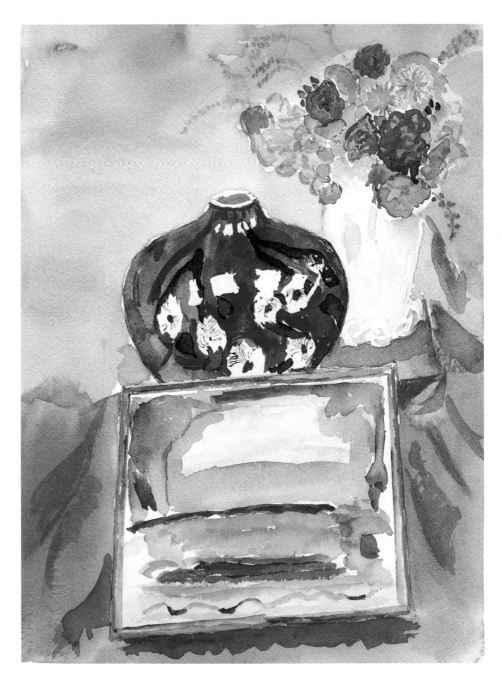

Patsy Highberg
COLORS AND SHAPES
Watercolor on paper,
16 × 12" (41 × 31 cm).

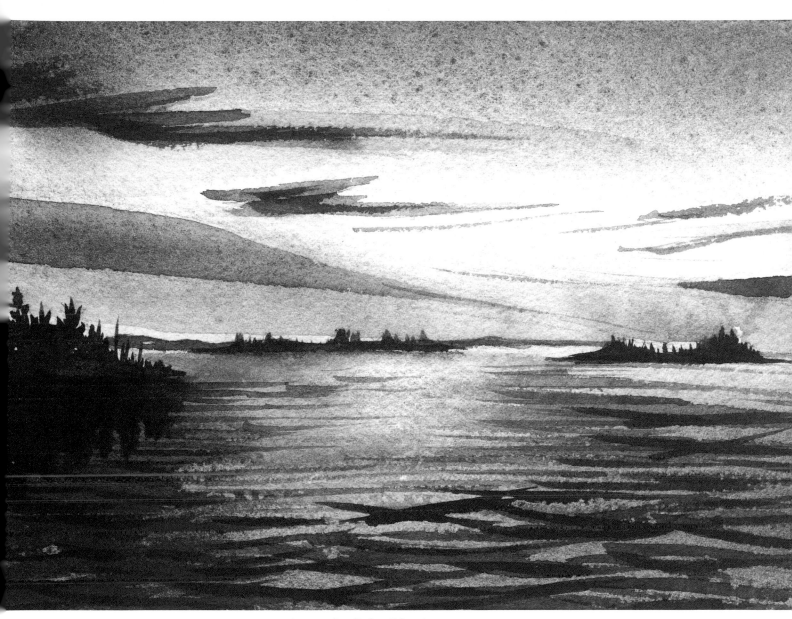

Annette Carroll Compton
SUNSET OVER LAUNDRY COVE
Watercolor on paper, 4 × 6" (10 × 16 cm).

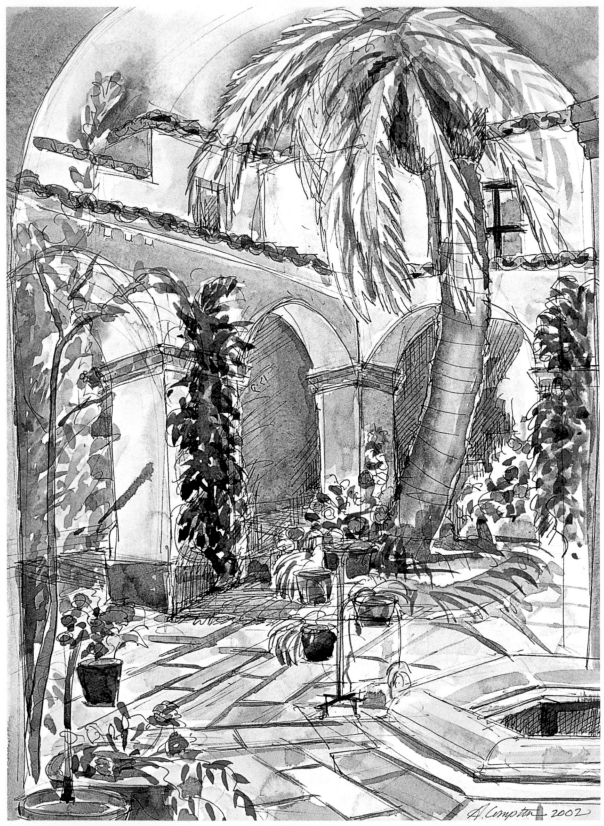

Annette Carroll Compton
AT THE COLONY
Watercolor on paper, 16 × 12" (41 × 31 cm).

exploring gesture

Now we step into the frontier of expression. We will begin exploring what isn't visible, by drawing the energy of a subject. You can express this energy in your own descriptive gestures. It becomes palpable when you describe your feelings through your own personal mark. This lesson will help you discover what your energy does to express the energy you see in your subject.

Up until now, we have focused on some fairly "mind-oriented" tools to expand your visual vocabulary. But now, gestural drawing or painting is our focus, and that often involves loopy, expressive, scribbly, fast lines—not the descriptive line of the first lesson; this is the line that describes the thread of energy running through your subject. Gestural drawings may have a nonobjective result, but in time, combining gesture with other tools we've explored—edges, shape, value, and color—will lead us to dynamic, expressive images. Gestural drawing often asks you to use your heart over your mind. Whether you are comfortable there or not may surprise you.

I was first introduced to gesture drawing in a theater class. The teacher was convinced that we would understand more about movement if we could depict what another person was doing, using a few short strokes of vine charcoal on paper. This is a great way to warm up to a session of figure drawing. Once a week, we had a circle of easels set up with pads of newsprint and boxes of charcoal. One person would stand in the middle and strike a pose for no more than three minutes, so we had to draw fast. The teacher harped on and on about capturing the energy of the movement in our gestural lines. What was the emotion depicted by the person modeling? "Change!" shouted out by the teacher meant that the next person around the circle became the model, and we reacted to this new pose. It felt scary one minute, exciting the next.

After getting over the horror of running through page after page in our precious newsprint pads, we found we were learning a lot. Not only about capturing gestures on paper, but depicting them on stage, which I believe was the point, given it was a theater class.

A few years later, I took a fashion-illustration course. Affected gestures enhanced the shape of clothes. The way a model stood conveyed a mood, an energy. The gesture of the illustrator's brushstroke or line created the mood and design. Speed counted. With speed came confidence in my mark-making and line. We were encouraged to look for energy first, structure second.

THE "ISNESS" OF THINGS

Zen masters speak of awakening a "third eye" into a kind of contemplation—where eye, heart, and hand become one. Referred to by Frederick Franck in his book *The Zen of Seeing* as seeing the "isness" of things, depicting this essence, or what I might call the energy or soul of a thing, becomes the artist's dilemma. It is not with the mind that one captures this essence; it is with the body—our visceral senses. All of them—smell, touch, sight, even taste and maybe hearing—are tools we use to find the soul of our subject. Whether it is a tree or a toaster, there is an "isness," an energy that draws us to the subject of our painting.

Beginning painters often ponder what to paint. I remember worrying about that myself, until I had a teacher who put a lot of disparate stuff in front of us to paint—from cylinders to bones to mirrors to fruit. His philosophy was that it didn't matter a whit what we painted; it mattered how we depicted it. He asked us to use how we felt about expressing ourselves on paper to guide the marks we made. Toward this end, let's explore relaxing the hand, as we did instinctively when we were children.

SCRIBBLE DRAWING

Scribbling is one of the unsung pleasures of childhood. Who doesn't remember the simple joy of taking a crayon and moving as fast as you could with big loopy lines to fill up a large area of paper? It was an athletic event more than art! Try it now with your pencil. Start anywhere on a big blank sheet of paper and begin to scribble. Let yourself go fast or slow. Fill the page, overlapping the scribble. You'll notice that your hand is off the sketchbook. You are moving your arm from your shoulder and middle back, where your shoulder blades, or "wings," are. Unfurl your wings and let it rip! Enjoy the pleasure of mark-making.

HEART EXERCISE

florals

Place a single flower or a branch holding several blossoms in a vase. In one pencil mark, convey the direction of the flowers as they sit in the vase. In my example, this "energy line" curves gently as it rises, then breaks into two lines to guide the position of the daisy heads. Then use this line to guide the direction of a gestural drawing of the flowers. Quickly define the edges of the petals and the leaves. Keep your pencil moving the whole time, covering the page. Let your arm move freely and expressively. When you have finished your graphite sketch, try the same exercise with watercolors.

In my example, graceful tulips, with their long, drooping leaves, are a particularly good floral subject for gestural painting. The essence of the flowers are captured with fast, athletic lines and bold, gestural brushstrokes. For your initial pen drawing, depict the overall shape of the bunch. Then follow the direction of individual flowers and their leaves. Speed up where you need to, and slow down where it seems right. Enjoy observing each flower as you brush on color. Emphasize the places where your eye falls, where you are drawn energetically. Put that energy into your brushstrokes to convey the "isness" of the flowers.

which tool to use?

Drawing the complicated form of a crumpled paper bag requires seeing the underlying structure, the "almighty edge," and using gestural lines to convey its energy. Contour-line drawing alone is useless in depicting the volume of such a subject. Abstracting the volume in a gesture drawing, while considering its underlying structure, is the only way we can make our way through such complexity. Finally, adding form through color with a value shift will help clarify the complexity for viewers.

MIND-HEART EXERCISE

crumpled paper bag

Open a paper bag, and with all the energy you have, crumple it up. Take your frustrations out on this poor bag, and when you have done your worst to it, fluff it up a bit so it can stand and pose for you. Begin to draw the bag with a graphite pencil. Explore the lines that have been created by your energy; draw the whole shape, the lines—then detail and crosshatch the shadows. Notice how you feel drawing it. Are you bored, hearing your left brain complain that it's just a dumb old bag, not worthy of your time? Or does your right brain take over so that you lose track of time, engrossed in following the bag's angles and folds?

Do a second portrait of the bag, this time, with color. Combine the information you've gathered from studying the bag for your first drawing with the added gesture of your brush as you use it to convey line, form, value, and color. Add personal expression to your mark, and your painting of a humble paper bag can become a unique creation to be enjoyed by your eyes and those of other viewers.

Annette Carroll Compton
PORTRAIT OF A PAPER BAG
Watercolor on paper, 16 × 12" (41 × 31 cm).

your brushstroke is your signature

When we use a brush rather than a pencil, we call ourselves painters. When we become confident with our brushstrokes and can depict energy, drama, and life force, we call ourselves artists—ready to portray a wide range of subject matter, including the human figure. In preparation for painting the figure, one technique to explore is "memory drawing."

Ask a friend to pose for no more than two minutes. Copy the pose yourself with your own body. Feel the tension and where your weight rests in the pose. Observe the model carefully. At the end of the two minutes, have your friend leave the scene. Then use your own energy and mark to depict what you saw and felt. This is the essence of gestural memory drawing.

A brushstroke can also be made with energy. So often, I see artists "coloring" a shape with paint, never considering how they are applying it. Each stroke counts. Scrutinize the watercolors of Cézanne or Sargent to see the gifted, confident brushstrokes these masters use to depict the breadth of a scene. As individual as the name they sign to their works, their brushstrokes are their signatures. Your brushstroke is also your signature, and over time, it can become your friend. Beginning painters often dislike their brushstrokes because they may reveal a lack of confidence. I encourage you to explore yours. Create imaginary scenes out of brushstrokes, a painting a day for week. Let your watercolors flow to fill some of the wet spaces, versus specifically sculpting forms. At the end of the week, you will have seven little studies in your sketchbook. Study the brushstrokes of each. Are they getting more confident?

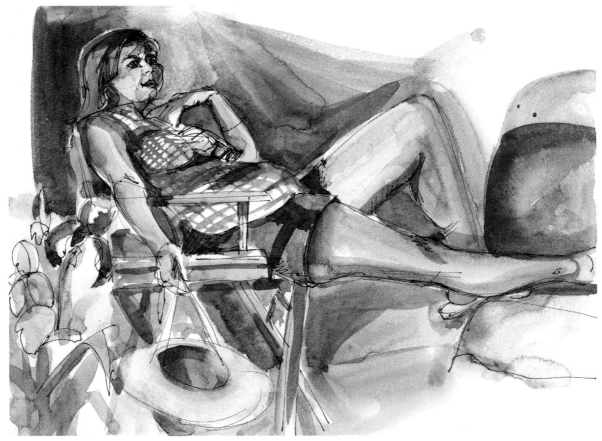

Annette Carroll Compton
MIRKA
Watercolor on paper, 12 × 16" (31 × 41 cm).

group brushstrokes puzzle

Using a print of a watercolor of your favorite artist, cut it up into six equal sections. Distribute the pieces among painters in your group, asking each to copy his or her piece as closely as possible. You should each do your best to copy the colors, but concentrate mainly on replicating brushstrokes. Come together again with your copied pieces and reassemble your "masterpiece." Compare it with the original. See if your mind and heart connected enough to reveal a similarity to the master's painting—but also note how each person's brushstrokes may differ from the others, as in the example shown, painted by six participants in a classroom exercise.

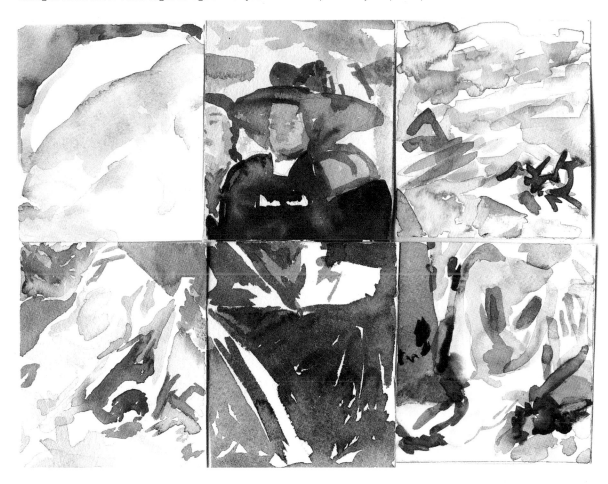

wet-on-wet, wet-on-dry, landscape

Find a photo that you like of a simple landscape. In my example, the setting is a shaded walk in a park. Tape a sheet of watercolor paper to your board and divide it in half. The left half will be a wet-on-wet shape study; the right half, a wet-on-dry brushwork study. Wet the left half, and brush pigment onto the paper, letting the colors blossom and blend as they dry. Work freely. Focus on establishing the lights and darks of the scene, capturing the large shapes only.

On the right half of the sheet, working on dry paper, apply your brushstrokes consciously, concentrating on form, building up from light to darkest darks. Follow the growth direction of the foliage. To capture nature's energy, let your painting become a web of crosshatched strokes of color. Keep your brush fairly dry so that your strokes do not blend into one another as the strokes did in your wet-on-wet study. In my example, see how the clean edges of color sit adjacent to colors of similar value, to create dappled light.

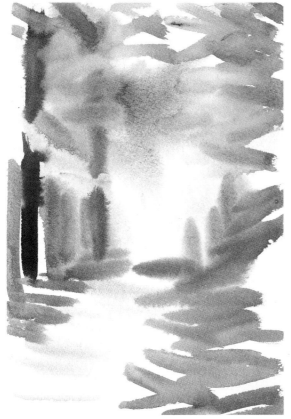

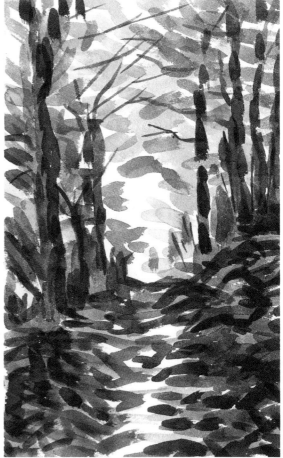

Annette Carroll Compton
MT. TOM WALK
Watercolor on paper, each 12 × 8" (31 × 20 cm).

line, form, pen, paint

By now, you know more about how to express yourself with line and how to fill a form with color. Combining the two offers myriad possibilities for any visual artist. Practice with a simple still life like the one shown here.

Using a strong gestural line, find the underlying structure of your subject. Maybe cross-contour lines can be suggested to show volume. Crosshatching your lines can offer value. Gesture can take off and become your signature, conveying both energy as well as realism.

Now add color. Using a wet-on-wet application, letting it dry imparts a gentle softness to your subject. If the forms become amorphous, use a pen to bring the shapes into focus, relying both on the "almighty edge" and hatching to express value. Or draw a light, gestural sketch and finish it with a strong, wet-on-dry composition, revealing your brushstrokes to convey confidence. Find your own signature by trying lots of different ways of understanding a subject.

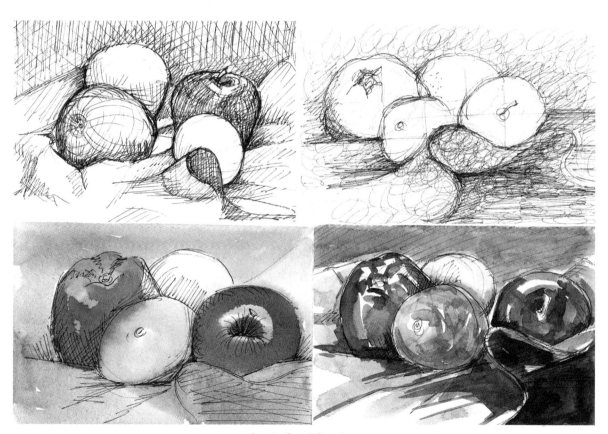

Annette Carroll Compton
MIND-HEART STILL LIFES
Watercolor and ink on paper, each 5 × 6½" (13 × 17 cm).

lesson 5 studies

MIND WORK Find a painting or drawing that attracts you, featuring linework or gestural brushstrokes. Using the same medium as the original work, try to repeat the energy of the lines or brushstrokes through speed, texture, or expression.

HEART WORK Each day this week, meditate for about five minutes in front of your sketchbook. Empty your mind and feel what kind of energy you have. When the time is up, begin to make marks that reflect the energy you feel in your body. You may find that each of the seven days of drawing will be different.

MIND-HEART WORK Ask someone to pose for you, for just fifteen minutes. Using pencil, pen, or brush, keep your marks quick and expressive. Start with a big, loopy scribble. If you use paint, focus on your brushstrokes rather than "coloring" in blocks of paint.

Annette Carroll Compton
RORI IN PROVENCE
Watercolor on paper, 8 × 10" (20 × 25 cm).

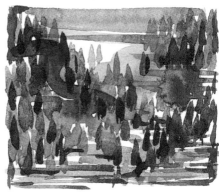
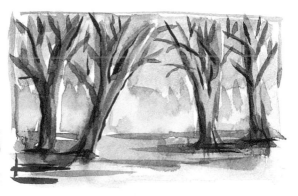

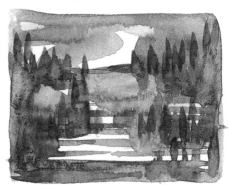

Annette Carroll Compton
Watercolor on paper, sketchbook studies, various sizes

These little studies were created as morning exercises, soon upon awakening. While none may become fully mature paintings, these studies are a way for me to gain confidence in my brushstroke, play with color, and explore the landscapes of my mind.

65

RIGHT: Sheryl Trainor
**LANDSCAPE,
INSPIRED BY VAN GOGH**
Watercolor on paper,
16 × 12" (41 × 31 cm).

*This student copy of a work by
Vincent Van Gogh uses heart-
felt energy in replicating the
animated brushstrokes and bril-
liant colors associated with the
great landscape artist.*

BELOW RIGHT: Annette Carroll Compton
**AN AFTERGLOW,
INSPIRED BY HOMER**
Watercolor on paper,
12 × 16" (31 × 41 cm).

*Copying a master like Winslow
Home is not easy. His mark is
confidence and bold, and his
mixtures are both complex and
subtle. The painting I copied, from
Homer's Cullercoats, England,
series, includes some of the most
beautiful examples of tines,
tones, and shades to be found
in watercolor art.*

OPPOSITE: Annette Carroll Compton
**STREET IN NYONS
AT THE MARKET**
Watercolor on paper,
12 × 9" (31 × 23 cm).

*During a workshop in Provence,
I spent about twenty minutes
drawing a street market as it
was ending. I set the stage with
a few clear pen lines, and then
began to enjoy and record the
gestures of the people milling
about. I added the color swiftly
during the last ten minutes.*

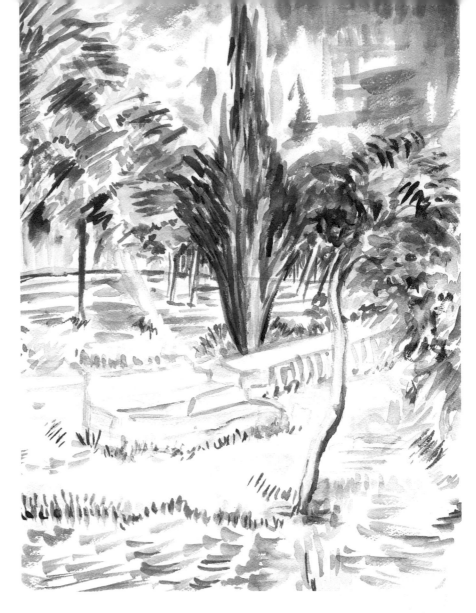

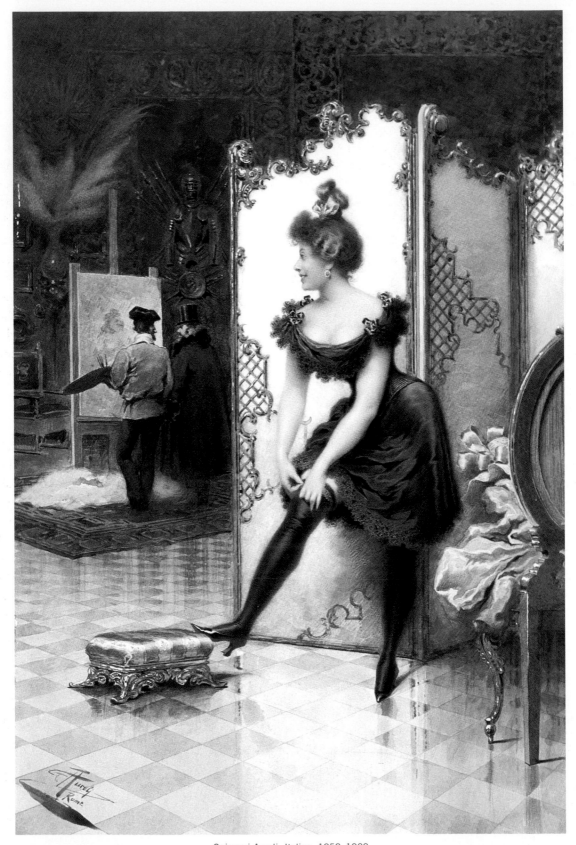

Guiseppi Aureli, Italian, 1858–1929
A MODEL FASTENING HER GARTER IN AN ARTIST'S STUDIO
Watercolor and gouache over pencil on paper, 16¹/₈ × 10¹/₂" (41 × 26 cm).
Sterling and Francine Clark Art Institute, Williamstown, Massachusetts. 1955.1545

in the studio

Within the calm, controlled environment of your studio, you can work from life or photographs. Many artists enjoy the comfort of painting in their studios, especially if they are away from the bustle of their living spaces. Studio artwork generally has a more realistic or crisp look, although it often lacks some of the spontaneity and carefree mark-making created on location. When painting indoors, you often use your mind to work through artistic problems more than you use your heart, although your heart may choose your still-life subjects. Of course, painting from nature can be also be done indoors, using photos and now, computer images, as aids. This lesson will focus on how to use all the tools we've explored so far with thoughtful refinement, to achieve a high degree of realism.

Studio painting, until the mid-1800s, was the norm, and the idea of an artist working anywhere other than indoors was considered odd, although some artists did venture out to paint landscape or architectural subjects. But personal, exploratory expression, as distinguished from commissioned work, was rare. A studio meant a livelihood, where paintings were created to be judged in "salons" or commissioned by critical patrons who had strong likes and dislikes. There are stories of everyone from the Medicis to Henry VIII returning commissioned artworks by the world's greatest artists—Raphael and Holbein, to name just two.

With the Impressionists, studio-versus-location methods began changing, and differed widely among artists. Degas dressed as a businessman at his easel and painted only indoors, often from sketches or from the newly invented photograph. Cézanne disliked studio painting. He felt that to paint from anything but nature was too indirect. Only on inclement days did he paint indoors, creating his famous apples and other still lifes, but his great drive was to work on location, as did many of his contemporaries. In the years since, Abstract Expressionism, Pop art, and other twentieth-century movements sent artists back indoors, where huge paintings and other large-scale works could be produced.

DEDICATED SPACE

I have many students who paint at their kitchen tables or on their beds on Sunday afternoons—as I did back in college—only able to dream about the luxury of a studio. A bold gesture doesn't always come easily when you're confined to a cramped working space that's temporary, and has to be cleared at the end of each painting session so the table can be set for dinner. So, if at all possible, try to dedicate at least a corner in your home where your painting supplies can be left out, ready to serve and nurture your artistic energy at a moment's notice.

On-site sketches can be developed in the studio and combined to create a watercolor tableau like this, depicting children at play.

SETTING UP A STILL LIFE

Choosing the subjects for still life can be infinitely appealing, and working indoors makes it easy to adjust lighting and experiment with spatial relations. For one entire winter, I found myself drawn to a rag doll and a wooden sailor, which I painted in various orientations in the company of natural objects such as shells, butterflies, fruit, and milkweed. It became not only an exercise in realism, but a narrative that told a personal story related to events in my life.

To create your personal narrative, collect objects that hold your interest for one reason or another.

Set them up often and draw or paint them, using the techniques we've discussed so far: line, form, value, color, gesture, and now, a new tool, composition.

COMPOSING A STILL LIFE

Begin with thumbnail sketches. Block off a 2"-×-3" space in your sketchbook, oriented horizontally or vertically, according to the shapes of the objects and spaces around them. Draw six or seven sketches of a composition before beginning a painting. Let your mind enjoy this planning stage, even though your heart may be impatient to get into the paint.

Annette Carroll Compton
SAILOR AND SOFT DOLL
Watercolor on paper, 18 × 10" (46 × 25 cm).

Having made a number of thumbnail sketches, by the time I readied my watercolor palette, I had examined the composition and its values thoroughly, and was then able to enjoy the process of layering and lifting colors to create a strong sense of realism in this depiction of objects my heart selected.

thumbnail sketches

Set up a series of objects. Consider their variations in shape, height, width, volume, and texture. Move the objects around until you find an arrangement you like. In your sketchbook, mark off a 2"-x-3" rectangle, and sketch a thumbnail layout of the objects. Mark off another rectangle and do a value sketch as well, utilizing a five-tone scale to map out the lights, grays, and darks of your composition. On a third rectangle, change the arrangement of your objects, and make another thumbnail sketch. These should take no more than ten minutes each. Rearrange the objects again and make yet another sketch. As you draw, you are absorbing information about the objects, as well as making a plan for the painting you will create, based on the thumbnail sketch that pleases you most. As a guide, refer to the thumbnail sketches that led to my sailor and doll watercolor.

working from photographs

Using reference photography has become second nature to many of today's fine artists. In earlier times, using photos was one of the "secret" aids a number of artists employed to capture realism. Artist David Hockney has written extensively about the possible use of lenses by artists in the past, even by the Old Masters. Today, Richard Estes, Chuck Close, and many other successful painters have demystified the idea of relying on photography to aid their work. But by their very nature, photos tend to flatten an image. So to bring a sense of depth to your work, when painting from photos, keep the following generalities in mind:

- Dark shapes tend to advance; lights tend to recede.
- Contrasting colors tend to advance; analogous tend to recede.
- Saturated colors tend to advance; desaturated tend to recede.
- Warm colors tend to advance; cools tend to recede.

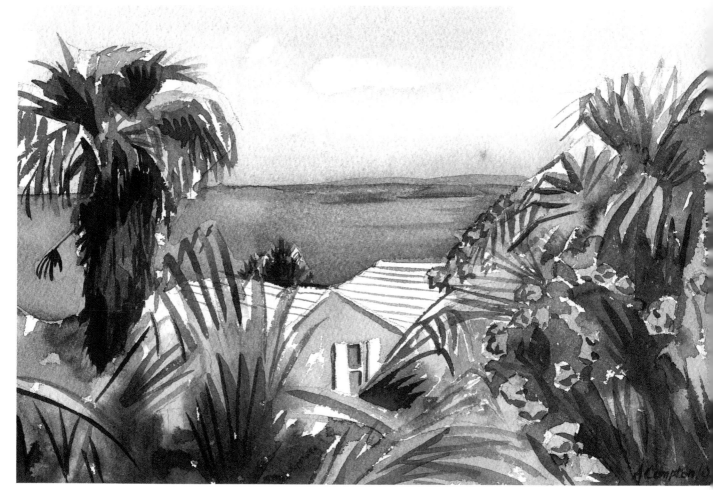

Annette Carroll Compton
BERMUDA FROM LENA'S HOUSE
Watercolor on paper, 8 × 15" (20 × 38 cm).

Photography can also come to the rescue when a scene you want to paint is in a place where it's awkward to set up an easel. That was the case with this view, which I painted in my studio, using snapshots that I made on location.

landscape painting from photos

Choose a landscape photo that you like for any reason: the place, the light, or the colors. With background music playing, study the photo closely, taking in the colors, shapes, and perspective; then put the picture aside. Wet the entire surface of a watercolor sheet. Choose and mix colors on your palette, and enjoy the process of dropping them onto the wet surface, letting the shapes mingle and drip. Paint for five or ten minutes with bold colors, glancing at the photo, but not slavishly copying it; just look at the big shapes, the colors, the values. Set your painting aside to dry. After about a half hour, go back to your painting. Referring to your photo again, use a pencil, pen, or dry, pointed brush to define some of the "almighty edges" of the forms as you draw on top of the color.

When you look at my example, note how I've sharpened details to bring more realism to the wet-on-wet base. But by having started with a heart approach to my painting, rather than letting my mind copy the scene precisely, the free foundation remains dominant. Do the same with yours. Draw into your color, letting your mark express what you see. Let your first layer of color be your inspiration. While you work, have fun imagining how it would be to visit this place in your painting.

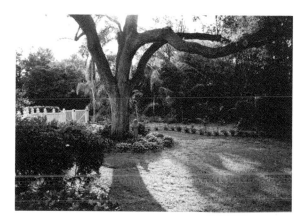

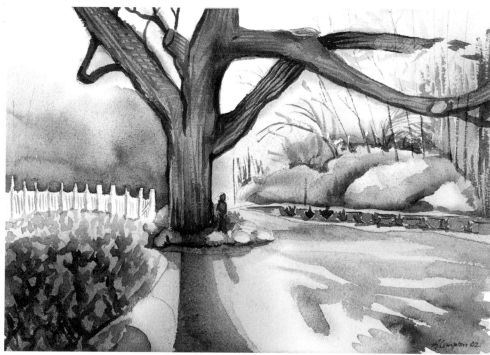

Annette Carroll
Compton
GARDEN
Watercolor on
paper, 12 × 16"
(31 × 41 cm).

tracing techniques

Illustrators who need to maintain a strong sense of realism often take tracings from photos to assist them in their commitment to detail. I recall the first time I watched my father use a tracing technique to produce his final watercolor painting. I thought he was cheating. In my mind, "real" artists didn't copy, and tracing was downright plagiarism! Then, as I became enamored of artists who created portraits for *Time* magazine covers in the 1960s, I wondered if they had help of some kind in achieving such realism. How did they do it?

Later, I was fortunate to work with Julian Allen, a well-known illustrator who showed me his techniques using photos. I rely on them now in varying degrees to achieve realism in my work, as the exercise ahead demonstrates.

MIND EXERCISE

working from a tracing

Trace a photo (or an enlarged, black-and-white photo-copy of it) into a clear contour-line drawing. Enjoy the process of breaking down the shapes of light and shadow, as well as the clear delineation of forms. Now, create your own carbon on the back of the tracing paper with a stump of soft graphite (6B or softer). Build up two layers of graphite and burnish it with soft tissue. Place this carboned drawing over a sheet of watercolor paper, and transfer the drawing by outlining it with a hard pencil (2H, 4H). When complete, remove the tracing paper and clean off any smudges on your watercolor paper. The drawing will be very light now. Touch it up with your hard pencil, and then apply paint, referring to your photo only to verify shapes and values. Build your paint layers slowly, from light to dark. As in my example: light washes of aureolin, quinacridone gold, and a wet wash of grays, blended from three transparents—aureolin, rose madder genuine, and cobalt blue.

PHOTOGRAPH BY JULIE IRELAND

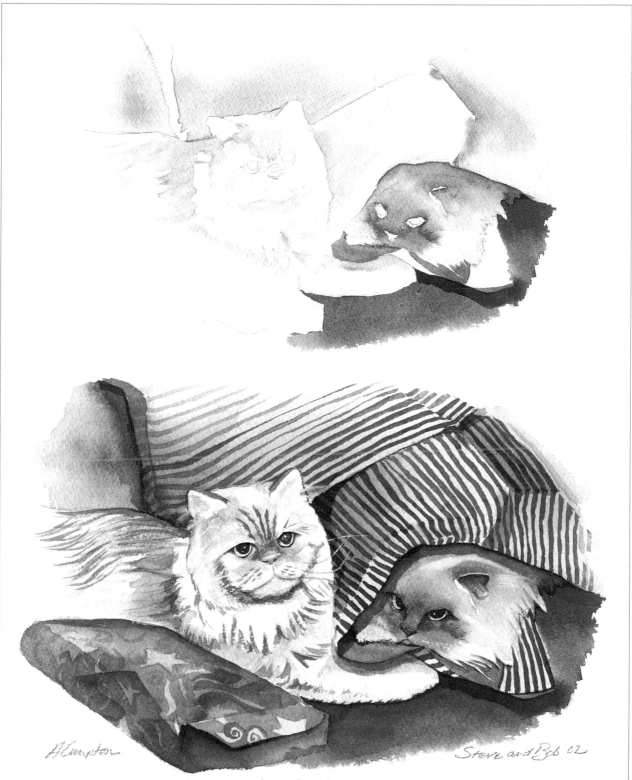

Annette Carroll Compton
STEVE AND BOB
Watercolor on paper, 10 × 16" (25 × 41 cm).

For my final washes and linear details, I used darker pigments, such as a anthraquinoid red for the stripes and a terre ercolano for the cat's fur.

using the computer

Many artists now accept the computer as a valuable tool. When I purchased my first computer in 1987, I thought at some point I would give away all my paints and simply use the mouse and screen to produce works of art. Some artists have done just that, but many more use it as a way to increase their work output or to archive it. But I still enjoy the physical action of painting and the flow of paint on paper, a process that is quite visceral for me. Besides, the learning curve on the more useful graphics programs can be steep.

An alternative is to connect with a graphic designer or production house that scans your work and prints it out as you need it.

For example, sometimes my line drawings are freshest when I'm working on inexpensive bristol, copier, or tracing paper. The line is vibrant, energetic, and full of the immediacy of the moment. As I go through the process of redrawing, there may be refinement, but a sense of freshness may be lost. There, the computer can help, as shown in the following exercise.

MIND-HEART EXERCISE

watercoloring computer scans

Choose subject matter that comprises at least five objects—either a still-life arrangement of inanimate objects or, as in my example, a scene from nature, inspired by several photos. Draw your subject realistically, using mostly line and a very slight amount of shading. Work on tracing paper. Now scan this image into a computer in a program such as Adobe Photoshop. After adjusting the drawing's contrast so that you can truly see the blacks clearly, print it on a 100-percent rag paper—and watercolor it with abandon. Print another, and try a new color scheme. Let yourself play with the process of making limited-edition color drawings in a variety of schemes, while maintaining the freshness of the initial drawing.

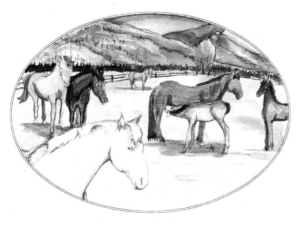

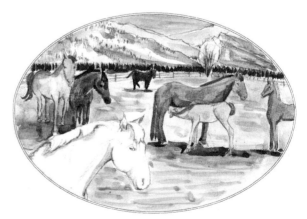

surrealist touches

The studio is where our imaginations can run wild. After becoming facile with drawing and painting realistic objects, perhaps you will want to explore fantastical settings for them. Or you may want to allow your hearts to explore shape and color, anthropomorphizing them into a fantasy world all your own. Study the work of some of the great surrealists or fantasy artists. The studio is where these artists used what they knew about line, form, and color to create intriguing worlds far beyond the limits of reality. Take advantage of the extreme versatility of watercolor by experimenting with the medium. For example, drop alcohol on your wet paper and watch the sudden irregular diffusions of paint that spread over the surface, creating effects that can distort objects enough to give a painting a surrealist flavor.

MIND-HEART EXERCISE

imaginary worlds

Using the amorphous forms you sculpted from Play-doh or clay in Lesson 3, place them in an imaginary, otherworldly setting. Start with a drawing, and try to map out how these objects interact. If a setting doesn't come to you easily, research one in a sci-fi or fantasy source on the Internet or in a book. This can be an exciting way to be master of your own world. Play with different backgrounds, odd perspectives, and light sources to heighten the fantasy, and choose unusual colors to create a mood.

Annette Carroll Compton
SPEED AND FALLING FORM
Watercolor on paper, 12 × 16" (31 × 41 cm)
and 16 × 12" (41 × 31 cm).

lesson 6 studies

MIND WORK Each day for a week, draw or paint one fruit, one vegetable, or one kitchen object in your sketchbook, working under a controlled light. Doing still-life studies of familiar objects helps build technique.

HEART WORK Organize your studio, if you're lucky enough to have one, or other working area, as a place in which you feel very comfortable. Make it cozy, yet energized enough to inspire creative work. Collect books and other materials that might stimulate ideas for paintings. If you have enough space, share your artist's haven with other watercolorists by inviting them over for group painting.

MIND-HEART WORK Do a painting from a photograph in your studio. Notice whether you find yourself pushing "exactitude" or "expressive" qualities in the painting you create.

GREAT
ARTISTS
TO EXPLORE

WHO USE THE STUDIO IN EXCEPTIONAL WAYS

Guiseppi Aureli

Chuck Close

Edgar Degas

M. C. Escher

Richard Estes

Artemesia Gentileschi

Hans Holbein

Jean-Auguste-Dominique Ingres

René Magritte

Gustave Moreau

James Rosenquist

Dante Gabriel Rosetti

Annette Carroll Compton
FRENCH COFFEE POT
Watercolor on paper,
9 × 8 " (23 × 20 cm).

This French coffee pot offers the complexity of chrome, glass, and mat black in one object. Transparent watercolors give the painting its luminous effects; staining colors produce its darkest shades.

Annette Carroll Compton
STILL LIFE IN THE STUDIO
Watercolor on paper, 12 × 16" (31 × 41 cm).

Working with pen and then painting with watercolor is a wonderful way to move between line and form. Set up studio still lifes featuring some of your favorite objects. These items were chosen straight from my heart, while I used my mind to select colors and determine value.

John Lynch
THE TREE
Watercolor on paper, 22 × 16" (56 × 41 cm).
Private collection.

on location

Here is where we combine line and color and leave more to chance. Once you venture out on location, there's less you can control. Light changes, and your mood is affected by nature. There is an immediacy in your line. You find yourself working more quickly, reducing judgments, and becoming one with the environment.

SIMPLICITY

Working on location causes us to simplify and limit our materials, pared down from the range of supplies we use in studio work—and that means planning ahead. How often do you see something that really attracts you, something that inspires you, but you find yourself emptyhanded? You have no sketchbook, no paints, no paper, and therefore, no hope of remembering all those interesting things that attract you. Even if you have a camera with you, the two-dimensional image it records will offer none of the interpretation you would bring to the scene if you painted it on site. This is where your mind part comes in: making sure that you get your materials together efficiently for on-site painting.

The heart part of working on location has to do with responding to your surroundings. Since the environment is constantly in flux, if you take an easily portable range of art supplies with you, you'll be better able to respond to the environment, rather than fumble with complex equipment. So if you keep your materials simple, I think you'll find, as I do, that you will be more likely to get outside often and work.

BASIC LOCATION MATERIALS

Start with a small sketchbook, large enough to record information, but small enough to carry easily. For ink drawings, I like both Sharpie pens and Itoya markers. I prefer working on site with a pen because it is neat and unobtrusive. Most beginning students complain, "But you can't erase a pen!" And that for me is the point. Working on site often means working fast; you have no time to second-guess yourself by erasing constantly.

Working with a pen means you go over your "mistakes," correcting them as you go. You are recording all that your mind is thinking. You must force yourself to take a shorthand of sorts of all the shapes around you.

With the items above and other basics, a short but complete list of location materials includes the following, which can fit nicely into a tote bag or backpack:

- small sketchbook
- fine-point pen and broad marker
- pencil and kneaded eraser
- watercolor sketchbook or small sheets of watercolor paper taped to small board
- folding travel palette with 18 colors
- a brush or two (covered travel brush is ideal)
- water bottle and small bowl to clean brush
- viewfinder

PHOTOGRAPH BY JULIE IRELAND

PHOTOGRAPH BY JULIE IRELAND

Two corners cut from matboard make a viewfinder, at left. Or use on location the viewfinder that's always with you: your hands, as shown above. Hold them up to whatever it is that you want to compose into a drawing or painting. Then on paper, position the objects in your composition as you saw them framed by your fingers.

plein air pioneers

We can thank Jean-Baptiste-Camille Corot for beginning to get us outdoors. There were painters who worked on site prior to 1840 or so, but the advent of photography seems to have driven French and other European artists to search for more innovative ways to depict nature. We can also thank painters on the other side of the Atlantic, like Frederick Church and Albert Bierstadt, who were commissioned to record the land being explored across America. This trend encouraged artists to move out of their studios into nature.

By the 1890s, the French Impressionists, particuarly, were routinely painting en plein air. Painters from abroad joined in. John Singer Sargent was known for taking groups of six to twelve American artists on summer painting expeditions to the Alps. Travel became a natural part of many artists' lives, and today, numerous painters work on site regularly, and painting workshops held in beautiful settings are well-attended.

But if you are an artist who has been quietly painting at your studio table, you may find working outdoors daunting. New things must be considered; the challenges of weather, materials, and seasonal changes are confronted. The suggestions and exercises in this lesson will help prepare you for inspiring observations on location.

MIND-EXERCISE

choosing nearby locations

Wherever you live, there is something to paint right outside your door. Choose seven different nearby sites, and note them on separate slips of paper that you toss into a bowl. Each day for a week, pull one out, pick up your tote bag of portable supplies, go to that site, and work. Look at each session as a new experience. Work small first, perhaps with pen only, then expand into watercolor. Notice how you feel on site versus how you felt in your studio.

PHOTOGRAPH BY JULIE IRELAND

fast paintings

The next time you're traveling, especially if it's to a place you've never been before, be sure to have your location supplies with you. Spend one whole morning or afternoon doing fast paintings. Stop and paint whatever you see. Work quickly; don't get hung up on the exactness of the forms. Spend no more than a half hour on each little painting, then move to another spot. Don't judge these fast paintings as conclusions, but rather exercises—just as musicians play scales—to help you appreciate and record places that delight you. It's also a wonderful way to remember places that you've discovered for the first time. In my examples, the four different spots in France that inspired these fast paintings remain fresher in my memory than if I had just recorded them with a camera.

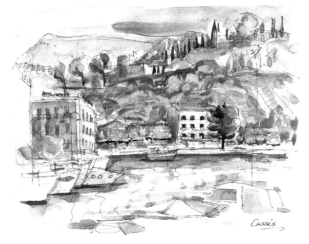

composing a painting on site

From the fast paintings of the last exercise, now we turn to creating more considered finished works. This calls for practice looking at the microcosm, the big picture, versus the macrocosm, the smaller picture—as if you were a telephoto lens. Working on location requires editing. Using your viewfinder is helpful in clearing distractions out of your line of vision. Give yourself a chance to look around before you settle on a spot. Consider your composition carefully. Notice how the lights and darks will attract the viewer's attention in the image. Move your viewfinder (hands or cardboard angles) around to see the variations in forms and the best boundaries to establish for them. Perhaps do one or two quick thumbnail sketches, but don't labor over them. Build your composition around the thing that caught your eye in the first place. Now zoom in and see if you can focus on a smaller, but more interesting, expression of the place.

DECISIVENESS

The major difference between painting on site and painting in the studio is often having to make quick artistic decisions, because of changing light, weather conditions, rapidly changing movements and gestures of people you may be trying to portray, or unexpected intrusions that can upset your concentration. If we are comfortable indoors, listening to nice music, enjoying our subject matter, there will be little reason for us to hurry. We can erase and think and labor and reflect. That is not to say that studio time isn't wonderful and very gratifying, but if we want to stretch ourselves, expand as artists, there will be nothing like working against time and changing conditions on location.

The next exercise, painting the same scene at different times of day, is a particularly challenging on-site experience, and especially when it's compressed into a short time frame, when the changes in light are most dramatic: just before sunrise or sunset.

Annette Carroll Compton
THE TETONS
Watercolor on paper, 5³/₈ × 14" (15 × 36 cm).

In composing a painting on location, when a setting like this presents broad vistas filled with nature's beauty, it challenges the artist to narrow in on just one area. A viewfinder is very helpful in establishing those needed boundaries.

painting sunrise or sunset

Two hours before sunrise or sunset, set up your easel outdoors. Tape four different sheets of paper to four different boards. Take along a timer that you can set for fifteen minutes. At an hour before sunset or sunrise, begin your first fifteen-minute painting of what you see. When the timer sounds, go on to the next sheet and set it for another fifteen minutes, and so on, until you have four separate paintings. Study the differences among them, and how swiftly colors altered around you. In the last fifteen-minute session, particularly, you could easily have painted fifteen more quick studies to show nature's constantly changing hues.

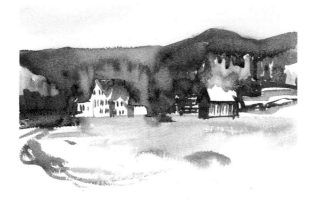

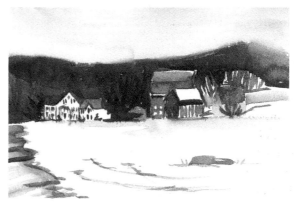

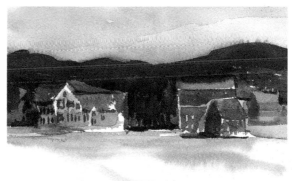

Annette Carroll Compton
SUNSET: FOUR STUDIES
Watercolor on paper, each 12 × 7" (31 × 18 cm).

These four paintings were done over the span of one hour. Each one took exactly fifteen minutes: upper left, 4:45–5:00 P.M.; upper right, 5:00–5:15 P.M.; lower left, 5:15–5:30 P.M.; lower right, 5:30–5:45 P.M. Notice how the values shift as the sun goes down. Luminosity is achieved by keeping the white of the paper fresh and open while contrasting it against strong darks.

what are you recording?

In a world where cameras, camcorders, scanners, and other devices for producing images are ubiquitous, why paint? This is a question you may be asked by passersby who encounter you on location at your easel or sketchbook, recording a vista. Obviously, the answer is that in addition to enjoying yourself creatively, you are recording more than the scene. You are storing information, taking notes, and stimulating your mind. How you feel on the morning you set up is as important as the image itself. As an artist, you are having a dialogue with your subject as the light changes, as people come and go. You are observing human beings relating to their environment—their gestures, their silhouettes, and their energy. Your reaction to a place cannot be divorced from the images you create. Painting on location requires spontaneity and acceptance of your idiosyncrasies as a draftsman.

"on location" via TV

You can be "on location" right at home, as you watch television. Have your sketchbook on hand as you view your favorite drama, sitcom, soap opera, talk show, or the nightly news. Draw the characters and action you see, using the frame of the television screen as the boundaries of your composition. Sketching a soap opera and other scripted programs (as opposed to talk shows or news) is most challenging; the camera shifts quickly to follow the action, so you have to work quickly—sometimes less than a minute per interaction. Several story lines and many different actors are there to be captured within an hour show. Start five or six drawings quickly, getting the gestures and really observing lines. Then, as the story evolves, switch pages, adding color and maybe even gouache on top to build up color. Have fun! Drawing characters from a soap opera and adding plot notes, as shown in these excerpts from my TV sketchbook, can help improve your speed and confidence.

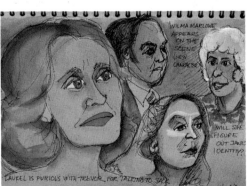

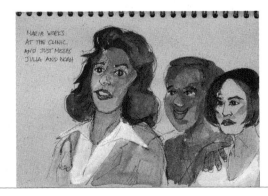

86

tool review

Let's review some things we have learned that can be helpful on site.

LINE is the essence of drawing or painting when you are short on time. However, the contour-line drawing tends to be slow, calculated. When working on site, often you must play a personal game of "beat the clock." So how can you move quickly and gain as much information as possible? Through gestural lines you will find shape plus energy.

FORM is what you see when you first walk into a space; it's usually the big shapes that impress you first. Maybe it's the walls, creating strong geometric shapes. Tabletops in a café may be seen as a series of ellipses. The cast shadows from a stand of trees may produce big, interesting forms. As the artist, you are being asked to simplify these things into bold shapes. Go for the big picture. Don't get seduced by details at this stage in your drawing.

SPACE the negative spaces around and between objects are as important as the objects in a composition. On location in nature's settings, the patterns are most complex. One form evolves into another. Use value and color to describe, for example, the overlapping forms of trees and the intricate negative spaces between and around their foliage.

COLOR is determined by both light and value. What is the overall color of the scene in front of you? Are you in a very brilliant setting or a dark, moody environment? If you don't have paints with you, make color notes. Write in the margins so that you can enjoy the experience of memory painting later.

TEMPERATURE in terms of color is often associated with climate. Is there an overall warmth or coolness to the place? Painting in Bermuda and painting in Scotland will dictate different palette choices. Record those climatic differences through color notes as well. Color temperature also refers to the emotional color of a place: hot red might connote excitement; cool blue, serenity. Which will you emphasize in a particular painting—the actual color, the climatic color, or the emotional color?

MOVEMENT suggests the energy of a place. Does a fast or a slow line best depict it? Is there a ton of detail or is it spacious and airy?

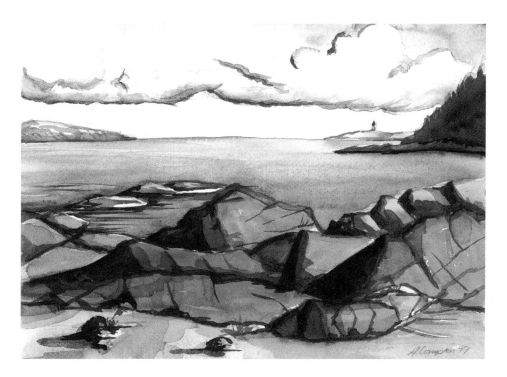

Annette Carroll Compton
SCOTLAND
Watercolor on paper,
12 × 16" (31 × 41 cm).

This seacoast painting was made on location on a late afternoon in September, where it was cool, but brightly lit. Notice the sharp value contrast between the dark rocks and the high, bright values in the sky. Quinacridone gold warms up the rocks; light-value transparent colors enhance the sky. Dark staining colors increase the luminosity of the water, without sacrificing depth.

location sketchbook

A sketchbook is an intimate recording of your experiences. It can be particularly poignant when you draw or paint at a location you've discovered for the first time. Often people ask me, "How long did that take you?" One answer is, "My whole life." Indeed, working outdoors is a continuous process that will go on reinforcing and building your confidence and skills.

visual journal

Keep a visual journal of an entire day on location. I often do this alone in a city. Move from café to museum to public market to bus stop. Pause at each location and do a small drawing, with some color to indicate light and value. Notice what the light does to each location. Try to find your own shorthand to describe people or foliage. Enjoy the sounds and snippets of conversations, and try to record them visually in your mark. Stay in the moment, releasing the pressure to create a "finished" painting. This exercise encourages you to find your signature as an artist. Fill a book, and chances are you will see the thread of your own heart coming through the work.

Sketchbooks are also a great way to record unique events in your life—or in this case, the life of my beloved dog, Howard, when he worked in a movie. I took a sketchbook on location and did these watercolors during the long hours that we waited between shots—adding notes, on Howard's behalf, that describe his experience as a movie star.

After lunch (I had Roast Beef) I sat with David, the Waiter, Wendy and Miss Jeanne Moreau. I think my big butcher shop scene got written out of the script—but that's show business. Besides, then it started to rain. Now, that's show business.

Joey told me I had to lie down in my scene today. I practiced for two hours.

Then the park police came by and told me I had to be on a leash to lie down... so I practiced in my "trailer".

DEVELOPING PAINTINGS FROM LOCATION STUDIES

On my workshop painting trips, I rarely have uninterrupted time to complete a painting. Instead, I rely on my visual journal, location sketchbooks, and photos to create paintings of subjects seen on location. When I return home, I may crop a photo to find a different focus and orientation for a scene or refer to my sketchbook for color notes and encouragement to stay loose and gestural.

For many artists, the minute we get to our studios, we slow down and get "careful"—which often translates into belabored painting. Keep your instinctive hand in the painting, and try not to fall back on those seductive lines in which many of us were taught to color. Of all the memories you retain from painting on site, remember how it felt to be fast and fresh, and where that occurred. Revisit that favorite place and move confidently and quickly through your painting.

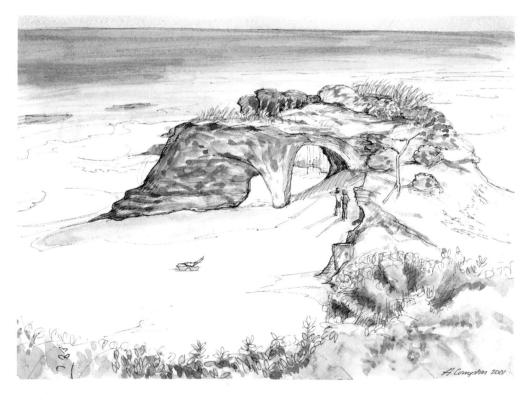

Annette Carroll
Compton
NATURAL ARCHES, BERMUDA
Watercolor on paper,
12 × 16" (31 × 41 cm).

Using the photo as reference and my sketchbook for color and value notes, I created this watercolor beach scene back in my studio, using liftable and staining pigments to create a bright, vibrant painting.

lesson 7 studies

GREAT ARTISTS TO EXPLORE

WHO USE GESTURAL LINE ON LOCATION IN EXCEPTIONAL WAYS

Isabel Bishop

Honoré Daumier

Raoul Dufy

Francisco Goya

John La Farge

Rembrandt van Rijn

John Singer Sargent

Edward Sorel

Henri de Toulouse-Lautrec

Robert Weaver

MIND WORK Make your studio portable; collect what you need to take on location. If you're a city person who travels by public transit to a nearby beach, lake, or amusement park, it's especially important that you keep your supplies compact. If you travel by car, see if you can paint comfortably in the front seat. Plan ahead so that all you have to do is paint, once on location.

HEART WORK Take your sketchbook to a different location each day for a week. Perhaps do one drawing at work, one in a café, one in line at the car wash, one at the supermarket, one at a concert, one at a sports event. If possible, take a few pictures in each location, should you want to develop your sketches into paintings.

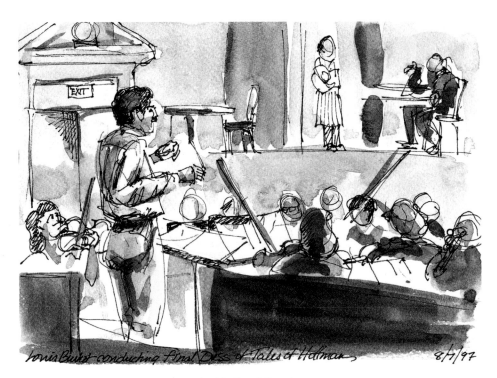

Annette Carroll Compton
OPERA NORTH: LOUIS CONDUCTING
Watercolor on paper, 6 × 9" (15 × 23 cm).

For several years, I have been fortunate to attend dress rehearsals of Opera North, a Vermont company, where I paint images of the singers and orchestra. These paintings were used as notecards for the company.

Annette Carroll Compton
AT THE TUNBRIDGE FAIR
Watercolor on paper, 12 × 16" (31 × 41 cm).

In September in Vermont, we have the local agricultural fairs. Tunbridge is well-known for its midway and maple-flavored popcorn. I spent a sunny day there drawing, capturing this and other colorful scenes.

Winslow Homer, American, 1836–1910
OSPREY'S NEST, 1902
Watercolor over pencil on paper, 21⁹/₁₆ × 13⁹/₁₆" (54 × 34 cm).
Sterling and Francine Clark Art Institute, Williamstown, Massachusetts, 1955.1502.

tints, tones, shades

In this lesson, you will learn how to develop three dimensions through form. Here, your mind and heart converge. Your knowledge of how to bring subtle variations of value to your subject matter leads to a meaningful visual interpretation, where grays serve as the setting for jewels of color in your painting. The possibilities are infinite, so let's examine how to develop your palette into the tints, tones, and shades that will bring the fascinating complexity to your paintings that you see in life all around you.

First, to define the three terms of this lesson's title: *Tints* are colors to which some form of white has been added to lighten them into a pastel version of their original hue. *Shades* are colors that have had black added to darken them. *Tones* are the complex colors that have had gray added to them. Deciding which to mix and where to place them in a painting has a lot to do with light, and how it touches your subject matter.

RESPONDING TO LIGHT

All things are perceived according to their response to light. Some artists strive to render objects realistically, emphasizing their three-dimensional quality. Others are unconcerned with literal representation, preferring to paint imagined objects. Either way, the rendering of light can convey space and emotion.

The challenge of depicting light requires a combination of mind and heart. We need our minds to understand the complexity of mixing tints, tones, and shades, while encouraging our hearts to respond with sensitivity to how light bathes subjects. Practicing the principles of color theory by mixing paints and using the white of the paper is an excellent way to improve your handling of the watercolor medium.

Another key to understanding the myriad ways to depict light is by observing the works of great masters. Rembrandt created portraits that were evocative and psychologically compelling by setting his subjects in a warm, chiaroscuro of gold and brown light. Georges La Tour, fascinated by the effects of candlelight, had his sitters illuminated by the warm glow of a flame. The Baroque period brought us painters whose work featured stage sets of moody and mysterious light. A good example is Artemesia Gentileschi, who painted the powerfully dramatic *Judith and Holofernes*. Surrealists René Magritte and Salvador Dali created spaces where light becomes disturbingly flat. Giorgio De Chirico painted surreal spaces depicting alienation by imposing odd light sources. Knowing how to create those varied effects with watercolor requires practice in mixing a variety of tints, tones, and shades, by creating and working with value scales.

Painting a still life of sugar lumps and an apple provides an excellent subject for practicing grays and the tint progressions of the colorful fruit.

value progression

Our eyes naturally respond to a gradual progression of light to dark. This progression can be broken down into a value scale, as we saw in Lesson 2. There, the example was building value primarily with pencil/pen lines. Now we turn to value scales with watercolor. Theoretically, such a value scale can include an infinite number of values, but for simplicity's sake, I suggest starting with a five-tone scale.

In watercolor, we lighten the value of a color by adding more water. This allows the white of the paper to mix optically with the color to create a tint. Use indigo blue (or any dark color) and set up a five-tone value scale of one-inch squares next to each other. Leave the left square white. Fill the far-right square with your darkest value of indigo—the pigment straight from the tube. Water down that value to about 50 percent and place it in the middle square. Once that is dry, put a 25-percent value to the left of the middle and a 75-percent value to the right of the middle. You should be able to see an even progression, particularly if you squint, which blends the color optically into a rich gradation.

An instructive and challenging experiment is to create a painting in one color—and the wider your value range is within that color, the more complex your image will be. In preparation for such a painting, expand your practice value scale to seven or nine

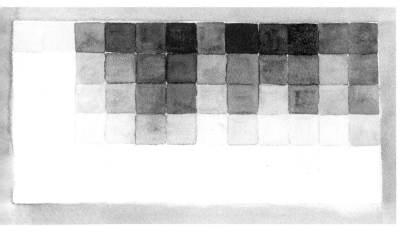

This shows tint progressions of colors in value scales, an ideal exercise for you to practice the balancing of pigment-to-water ratios.

tones. Especially if you want to achieve a high degree of realism with one color, a larger value range will give you more room for expression.

ADDING BLACK OR WHITE

Before the mid-1800s, watercolor was used mainly to help oil painters work quickly on location, and they often used Chinese white and ivory black to express the lightest and darkest values in a scene. When the obvious transparency of the watercolor medium came to be appreciated, many artists stopped using white pigment, mixing with water, instead, to produce tints. They also began blending colors to produce black, thereby relying on watercolor's inherent qualities to produce their darkest shades for a painting. Today, some watercolor societies even discourage participation of artists who work with white, because its opacity defeats the transparency of the colors. However, some colors such as cerulean blue and Naples yellow have white in them, so the "legitimacy" of using white can be much debated. As for mixing blacks, carefully balanced blends create subtle shades. Practice to achieve these interesting mixtures. Let's begin by mixing tints.

TINTS

As shown in the five-tone value scale, diluting pigment with water creates tints; the white of the paper comes through, allowing a lighter value of the color to appear. Some watercolor pigments are more transparent than others to begin with, so they can be used naturally as tints; aureolin, rose madder genuine, and cobalt blue give us the lightest values. Go back to your color circles from Lesson 4 and mix those three colors together. In learning to mix tints, experiment with other colors as well; all colors have an ability to be tinted. As for ever using white pigment, if you're tempted to do so, you'll be in good company, for despite those watercolor societies that shun painters who use white, it should be noted that both Winslow Homer and John Singer Sargent created beautiful effects by adding touches of opaque white to many of their splendid watercolor paintings.

SHADES

There are several ways to achieve shades. Perhaps the simplest way is to add black pigment to another color to produce a darker shade of that hue. Sometimes applying the full-strength of a dark color straight from the tube will produce the shade you need. However, some dark watercolor pigments used "pure" will show a loss of transparency. But if you choose clear, quinacridone-based pigments, you can create rich, colorful darks. A mix of staining pigments also creates beautiful deep shades; try mixing a trio of staining colors, as shown in Lesson 4. What a rich black they create! Finally, you might mix two complementary colors to create a lowered note of a neutral, bordering on black.

mixing neutrals

Many beautiful paintings depend on the subtlety of gray in a muted or low-light environment. These three color triangles explore colored grays. First, place the primaries (red, yellow, blue), in the corners; secondaries, (orange, green, violet) between them. The remaining triangles are mixtures of all three primaries, with an emphasis on the grayed primary you wish to create: a blue-gray, a yellow-gray, or a red-gray. Another method is mixing the primary with its complement—that is, a secondary color opposite it on the color wheel: for example, red with green, yellow with violet, blue with orange. This is always a good way to add a colorful gray to your composition.

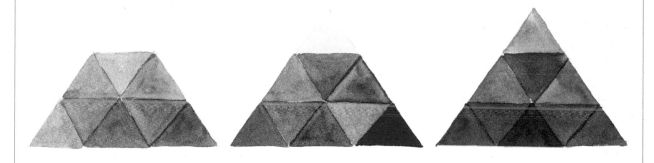

creating tints, tones, shades

Draw an equilateral triangle, placing a circle at each point. The top circle will hold a hue; in my example, red. The lower-left circle holds white—either the white of the paper, as shown, or white paint; the lower-right circle is for black. Draw three circles along each arm of the triangle. To create *tints* along the left axis, vary the ratios of white/red; to create *shades* along the right axis, vary the ratios of black/red; for the grays across the bottom axis, vary the ratios of black/white. After these value progressions are completed, take an equal amount of red, black, and white to create the tone for a circle in the center. Practice this exercise by substituting other hues for red.

TONES

These are the subtlest of all color mixtures—the ones that have gray added to them to make a tone, a neutralized color. In watercolor, they can easily appear dull if not thoughtfully mixed. With oil paint or acrylic, gray is produced by mixing white and black together, then adding a color to it to create a tone. But as we know, when you add white to watercolor, you lose transparency, and the toned color becomes flatter when based on this type of gray. So how is toning accomplished in watercolor?

One way is to use the naturally occurring muted pigments, namely, earth tones. For instance, yellow ochre could be said to be a tone of yellow, for it appears to have been desaturated by a neutral gray. You can also create a gray out of three primaries or out of two complementaries. Try adding this gray to a saturated color to see how it changes the hue to a desaturated tone. As you combine colors and add water, don't dilute the blend too much. Instead, try to maintain the saturation of the pigment so the color stays rich.

Tones are often created by accident, through glazing successive layers of color as we "correct" a painting. This layering process can actually help a painting to become richer, but beware of it becoming overworked. This is where your heart must be fully connected to the painting process. Knowing when to stop is being willing to trust that you have left enough mystery for the viewer to fill in, and enough realism to grasp the image.

Robert H. Seaman
AURORA IN NIGHT SKY
Watercolor on paper,
5 × 7" (13 × 18 cm).

By using blue-toned paper, this artist worked from the middle value of the background, adding in bright pigment whites for the highest values and black pigments for the lowest notes, to produce this compelling monochromatic watercolor painting.

Annette Carroll Compton
WAVES
Watercolor on paper,
12 × 16" (31 × 41 cm).

This began as a demonstration of a blue value scale, but as the rhythmic curves gradually became a sea of waves, it turned itself into a painting. The highest values, the whites, are created by leaving the paper unpainted. The tones are made by adding gray to the base color of French ultramarine.

Robert H. Seaman
SHARK
Watercolor on paper, 13 × 8" (33 × 20 cm).

Here is a beautiful example of how a skilled watercolorist uses the principles of value to depict an unusual play of light. Look at how the complexities of grayed tones contrast against the luminous tints and deepest shades.

value symphony

This exercise will help you find the right water/pigment balance, while tuning your eye to the sensitivity of value shifts. Premix your paints into five different values. Make a pattern of shapes that can be broken down into five-tone value scales. Fill these spaces with the logical value progression of tints, tones, or shades. In my example, look at how some shades of colors are desaturated, giving them less emphasis in the composition—whereas the bright, pure colors leap to your eye.

Annette Carroll Compton
CELESTIAL SYMPHONY OF VALUE
Watercolor on paper, 16 × 12" (41 × 31 cm).

Annette Carroll Compton
**EGGS ON A
PERUVIAN BLANKET**
Watercolor on paper,
12 × 12" (31 × 31 cm).

This still life is set in the natural light of the room in which it was painted. The glow comes from the brightly colored blanket, rather than from the low light source.

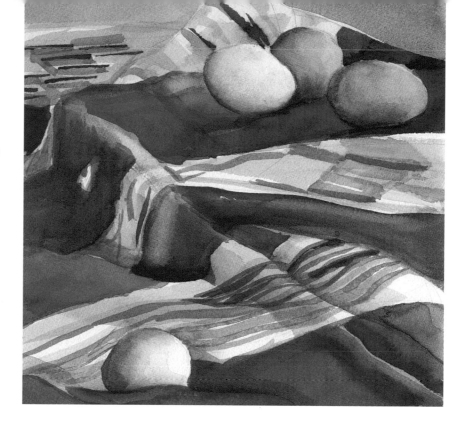

Annette Carroll Compton
EGGS, EGGPLANT, LEEKS
Watercolor on paper,
16 × 12" (41 × 31 cm).

The intensity of this painting comes from the contrast of dark darks and light lights, illuminated by a strong light source channeled directly on the subject.

lesson 8 studies

HEART WORK Work on a painting for one hour. Then stop, no matter where you are with it, and go on with other activities. Go back to the painting the next day at the same time. By forcing yourself to get away from a painting, you can evaluate it with a fresh eye. If you incorporate painting into your daily life, stopping and starting become easy.

MIND-HEART WORK Set up a small still life and see what happens when you light it from behind. Record those values in a small graphite drawing. Then change the light source by moving it to the front of the objects, and record those values in a second drawing. In each case, progress through values and see how the tints, tones, and shades expand your perspective and depict the reality you wish to portray. Choose the version that appeals to you most, and translate it into a watercolor painting.

Judy Laliberte
SCALLIONS, GARLIC, AND ONION
Watercolor on paper, 9 × 12" (23 × 31 cm).

The cast shadows in this student's painting contribute strong dark values that contrast effectively with the mellow wood tones of the cutting board.

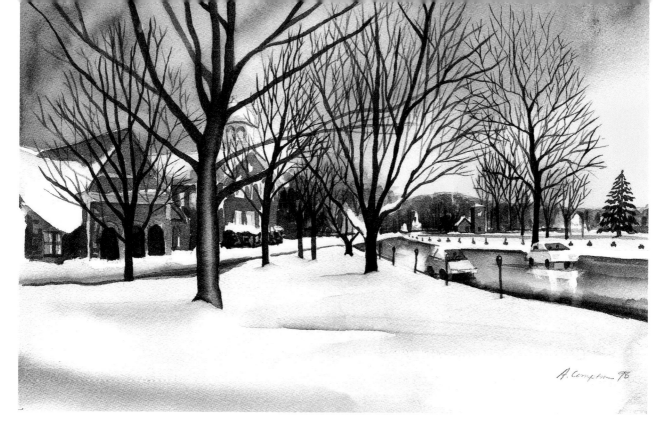

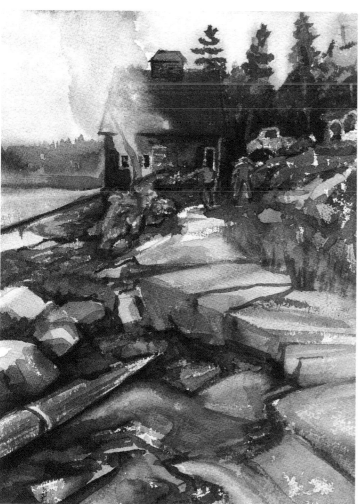

ABOVE: Annette Carroll Compton
IN THE PINK
Watercolor on paper,
12 × 16" (31 × 41 cm).

Sunset is an ideal time to capture dramatic lighting effects, especially in winter. Long shadows in cool, dark tones contrast against the tints of unusual pinks and oranges.

LEFT: Annette Carroll Compton
**BURNING BRUSH
ON ISLE AU HAUT**
Watercolor on paper,
16 × 12" (41 × 31 cm).

The foggy Maine coast offers painters the opportunity to explore the beauty of colored grays to create a mood through desaturated and midvalue colors.

Annette Carroll Compton
MOONLIGHT
Watercolor on paper, 18½ × 11½" (47 × 29 cm).

creating mood

Although the local, or literal, color of an object is obvious, it can be dramatically modified by shadow and the colors surrounding it. Your left brain, which accurately names colors and subjects, becomes a hindrance when you are trying to describe a mood created by light or lack of it. It is our intuitive vision that moves us to explore unlikely colors to create a mood. Your heart is the repository for the feelings you want to convey. Being a painter is about communicating, not simply recording.

PAINTING DRAMATICALLY, TELLING A STORY

As artists, we have an opportunity to express a range of emotions in our work, to paint images that reflect how we perceive our world. Many people strive for moderation—an even keel through life to keep them steady and less reckless than the artists of the world. But being an artist often means living with a heightened sense of awareness, using your sensibilities, experience, talent, and skills to express what you feel through the stories you tell with paint.

Painted stories are often filled with intriguing mystery. One such work that moves me deeply is a painting by Georges de La Tour of a young woman seated at a table with a companion. She holds her hand over a candle flame. The light from the flame illumines the entire composition; the hand glows with a transparent brilliance. Is it about danger? Is it about contemplation? Each viewer will have a different take on its meaning. The personal mood we bring to a painting affects our reading of its story. Imagine being able to create an image so universal and so rich that it can move with the viewer's mood, not as an ambiguous statement, but as an evocative connection to the heart of another person. This is the joy of being an artist, to touch viewers emotionally. To achieve that goal requires knowledge of technique and one of its most critical aspects: the skill of rendering light.

HOW LIGHT HITS OBJECTS

When we analyze how light falls on an object, creates shadows, and breaks down into values, these are the terms to consider:

- **HIGHLIGHT** is the spot or spots of highest value, where light is brightest, reflecting off the shiniest surface.
- **CAST SHADOW** is the shadow of an object as it falls on another surface—the shadow created by the object blocking light from hitting that surface.
- **AMBIENT LIGHT** is the light reflected around an object, which may or may not lighten the surface of the object.

The following exercise will reinforce your understanding of how different light sources fall on objects, and how to depict those patterns in your painting.

Annette Carroll Compton
STOKING THE FIRE
Watercolor on paper, 12 × 16" (31 × 41 cm).

The fire's glow provides the main light source here, casting warmth over the entire scene.

frontlight, backlight

To study chiaroscuro effects achieved by *direct lighting*—lighting directed toward the front of objects—place an egg and a dark form, such as an eggplant, on a dark drape. Aim a single light directly on the objects. Paint what you see, building up from light to dark, layering some of your darker paints, one over the other, to achieve the moody contrasts of the setup. This chiaroscuro effect can be described as light emanating from the dark, with subtle gradations of light and dark value giving form to the objects, heightening their visual appeal.

To study *backlight*, sometimes called *contre-jour* lighting, place your egg and eggplant on a surface where it can be lit from behind. In my example, I used a windowsill that receives bright backlight on a sunny morning from another window across the room. Again, paint what you see. The white egg, lit from behind, will defy your mind, for it is in deep shadow now. How could something so white be so dark? The light source from behind changes the values of the objects completely. Now you are confronting the challenge of having to render brilliant light that is blocked by the silhouette of your subject.

<div align="center">

Sheryl Trainor
FRONTLIGHT STUDY
Watercolor on paper, 7¼ × 11" (18 × 28 cm).

</div>

A good way to practice frontlighting is by setting up a block, an egg, and a cylinder on colored paper, with a strong, direct light source in a darkened room, as in this student's successful study.

<div align="center">

Carol Orgain
BACKLIGHTING STUDY
Watercolor on paper, 7½ × 11" (18 × 28 cm).

</div>

A slightly overhead perspective adds interest to this student's backlighting study of three geometric shapes, casting their shadows forward. Notice how subtle color, picked up from the turquoise, enlivens the cast shadows. Hatching in pencil was added to deepen the shadows.

backgrounds

Often I hear beginning students say, "I didn't know what to do with the background, so I just left it alone." But soon students learn that a background is certainly not incidental to a painting, and ignoring it can diminish the outcome considerably. What you choose to do with everything in your composition affects your viewer. Once again, light is the key to creating an interesting setting for your subject, just as background is integral to your choices. One of those choices is using negative space to enhance a background, as the next exercise demonstrates.

negative space

Depicting the air around an object—its negative space—can contribute importantly to the success of a painting. To demonstrate this prinicple, find a broad-leafed houseplant and give it strong frontlighting. On a sheet of watercolor paper, do a contour-line drawing of the plant, and then wet the entire sheet. Wash a clear, transparent yellow green over the whole sheet; in my example, aureolin and Winsor green (blue shade). Note that the wash is pale enough to allow the pencil lines to show. Then, in the lower area, I used rose madder genuine and permanent rose. Although those pigments seem powerful when applied, they will dry to the light value shown in about fifteen minutes.

For your second layer, mix a strong dark green; in my example, the mixture is sap green and Winsor blue (red shade), applied over the foliage area—but only in the negative spaces around and between the leaves. Let this glaze dry, and then proceed with your darkest darks. As shown in my final painting, I used Winsor green and alizarin crimson, particularly for the final shadows. Notice that by painting everything but the actual subject (the plant itself), you can achieve a strong sense of three dimensions while solving the "backgound problem" by filling it with strong negative shapes.

 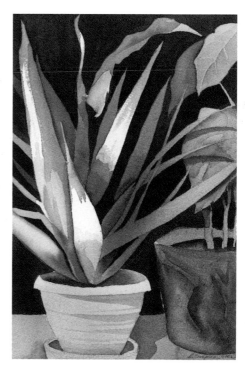

Annette Carroll Compton
HOUSEPLANTS
Watercolor on paper,
17 × 11" (43 × 28 cm).

gessoed board

Find a black-and-white photographic portrait that shows good contrasts of light and dark values. On illustration board, apply three coats of acrylic gesso. Let it dry completely, overnight. The next day, apply a middle-value watercolor paint densely all over the board. In my example, I've used French ultramarine blue. Once it is dry, begin lifting and wiping out paint to create white and paler areas, allowing many values to appear. Paint in darker values of the color where needed, to replicate the value effects of the photograph. Use your brush expressively to add line and form where necessary to enhance your painting. The technique is sculptural in a way; let yourself sculpt the image. This technique can help you see value in a new way, rather than the conventional approach that begins on a white ground.

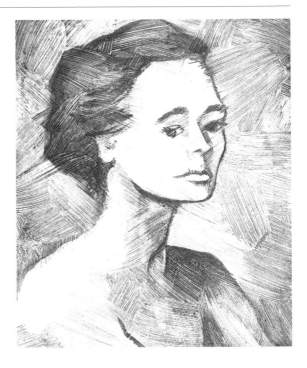

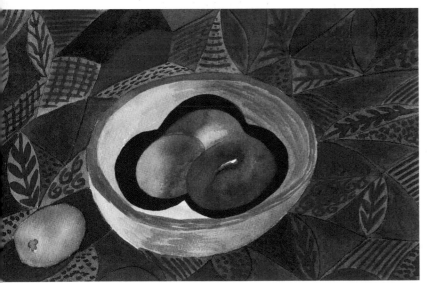 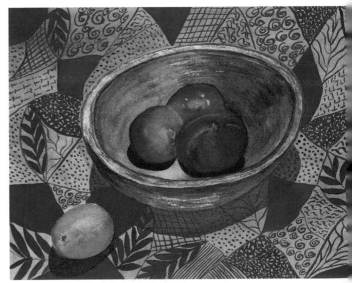

Judy Laliberte
STILL LIFE
Watercolor on paper, each 12 × 16" (31 × 41 cm).

These two imaginative interpretations of the same still life were created by a student whose work demonstrates beautifully how a strong background can transform a simple subject into a far more creative and colorful composition.

contrast magic

Backgrounds become even more challenging when we consider the impact of color on them, and how complex our chosen colors can be. Just when you've begun to get comfortable mixing tints, tones, and shades, you discover that when you put one color on your paper next to another, they do not always behave as you had hoped. That rich violet dried to a muddy maroon; the bright mixture you placed wet-on-wet into a negative space dried to a dull brown; and worst of all, a beautiful blue jar that you thought would sparkle on a luscious violet-shadowed background fell flat. But knowing a bit of the intellectual gymnastics of color theory can overcome some of these problems and help create wonderful drama for you and the viewers of your work.

Josef Albers, in his 1963 treatise "The Interaction of Color," reminds us that color perception is completely relative. The red of a sign in Texas is perceived as a different red from the red seen in Vermont, because light in the two different states arrives at different angles from the sky. Green mountains versus gray rocky flats create differing patterns of light and shadows. As a painter, your mind must be flexible and your heart open to the varying qualities of your environment.

The next exercise demonstrates what happens to an object set against two very differently shaded backgrounds. This is the drama of "simultaneous contrast," which states that any color is affected by any other color against which it sits. Albers did ceaseless experiments in his paintings of squares to examine this phenomenon.

MIND EXERCISE

simultaneous contrast

Find a blue vase, either a cobalt glass or a pottery version with a strong color. Set the vase on a neutral burlap or linen background. Light it strongly. Do a watercolor painting, trying to match the colors exactly, including the background—as in my example, a neutral with a blue tone, setting off my upside-down glass.

Now do a second painting of the same subject. This time, alter the background to include the complement of blue in it (orange), and observe how much stronger a painting it is, because the warm tone in the background enhances the blue of the vase. This "mind trip" from color theory can do a lot to move the heart of your viewer.

Annette Carroll Compton
COBALT GLASS
Watercolor on paper,
16 × 12" (41 × 31 cm).

night scenes

For Scandinavian and Russian painters, night scenes are a necessary part of painting landscape during at least half their year. When I was first struck with this fact, I became eager to paint a night scene myself. Being aware of the value of color in my palette made it more possible to achieve the interesting glow of incandescent lighting on a nighttime street or the cool glow of the winter moon on snow. Scenes of anything in the dark can create a wonderful mood in a painting. Using your knowledge of color can help you achieve the dramatic results shown in these night paintings created by two talented students.

Sally Sherman
BERMUDA TRIANGLES
Watercolor on paper,
12 × 7" (31 × 18 cm).

Strong geometric shapes and a cool palette set the stage for this student's impressive, mysterious night scene.

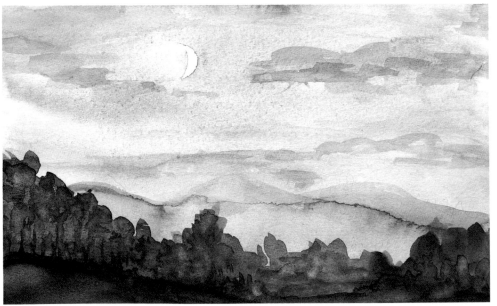

Carol Orgain
OUT OF MY WINDOW
Watercolor on paper,
7 × 12" (18 × 31 cm).

The progression of value, from darkest darks in the foreground to lightest lights at the horizon, gives this student's night scene its tranquil beauty. Utilizing the white paper for the moon allows it to shimmer against the darker blue sky.

self-portrait: your personal statement

Over the years, I have done many self-portraits—some for classes, some for self-knowledge, some because I am a free model! For whatever reason, the observation of my own face in a mirror can be both disturbing and enlightening.

I remember one night seeing my reflection in a dark kitchen window and deciding to paint it. My father was in the process of dying, and I was in transition. I thought my portrait was terrible, so I tossed it into the trash. The next day, when our housekeeper emptied the wastebasket, she found the painting and stood looking at it, transfixed. "I had no idea how much sadness you're feeling. I understand. I've felt the same way." In that moment, I learned that whatever I think about my work really doesn't matter. What counts is what moves our viewer.

I tell this personal story in the hope that you will benefit from my experience, by not being too judgmental of your own work. I encourage you to paint what you see—even with the limited capacity you may think you have. Your opinion of your work is often suspect, since the expectation of your mind is usually at odds with what your hand can create or your heart dares to say. Dare to reveal yourself to people. Tap into your heart and touch the heart of someone else, rather than clinging to the "rightness" of your work. If you share your mood, you'll create a new one. Portraiture, of yourself or others, is a good way to practice.

MIND-HEART EXERCISE

portraits of others

Ask a relative or friend to sit for you in a semidark room. Aim a strong light to the side of your model, and paint what you see. Work slowly, building up light to dark. In my example, the most transparent primary colors—aureolin, rose madder genuine, and cobalt blue—were applied first. Then I used the deeper, more resonant staining colors—quinacridone gold, alizarin crimson, and Winsor blue—to achieve deep, colorful shadows. As glazes of color are built up, luminous blacks come into play, and out of the strong side lighting, the subject emerges.

Annette Carroll Compton
TRISH READING
Watercolor on paper,
16 × 12" (41 × 31 cm).

lesson 9 studies

GREAT
ARTISTS
TO EXPLORE

**WHO USE
LIGHT IN
EXCEPTIONAL
WAYS**

William Blake

John Constable

Honoré Daumier

Artemisia Gentileschi

George de La Tour

Gustave Moreau

Rembrandt van Rijn

J.M.W. Turner

Jan Vermeer

Jamie Wyeth

N. C. Wyeth

MIND WORK Take a twenty-minute walk with your sketchbook at night or early in the morning, before the sun has come up. Sketch a value study of the scenery in low light. Use crosshatching to fill the various values quickly. Study how light recedes into darkness.

HEART WORK From a newspaper or magazine, find a story that moves you, and paint an image that is influenced by the story. Is it dark or light? Do you feel you want to paint realistically or nonobjectively? Let go of expectations about what you are "supposed" to reveal. Let your heart guide the painting. If the story is a tragic and troubling one, making an image of it can become a catharsis for you, giving you a deeper, more compassionate understanding of the news, rather than simply passively receiving it from television or print reports.

Annette Carroll Compton
NEWS STORY
Watercolor on paper, 12 × 16" (31 × 41 cm).

This painting was inspired by a disturbing article in The New Yorker *about the plight of the Kurds, which included a compelling description of the Kurdistan prison to which women and children were arbitrarily sent. The story stayed with me for weeks, until I spent time portraying it on paper, which was a cathartic experience for me.*

Everett Webber
PERKINS COVE
Watercolor on paper, 30 × 22" (76 × 56 cm).

emotional color

Choosing an expressive palette based on color and value gives you a unique voice as a painter. You may become daring enough to experiment with colors that do not appear to be the same as in reality. Like the Fauves—so-called because they used color "wildly"—you can create a palette that departs from local, or literal, color and is based more on personal expression, to make an emotional statement about your subject matter. Even a slight shift from local color can create a more exciting painting.

VALUE AS EXPRESSION

This concept of exploring color for itself is evident in most of the work of Post-Impressionists Pierre Bonnard, Edouard Vuillard, Paul Signac, and Vincent Van Gogh. These and other artists were influenced by the heightened value scale produced by black-and-white photographs, and they translated those bold contrasts of lights and darks in their palettes to create mood in a painting.

Today, I find that the most innovative watercolorists are also those who dare to move away from local color and find their own color interpretation of subject matter based on feelings, not reality. Their freedom of expression is supported by a confidence that comes from knowing how color and value can be exchanged.

To gain that awareness in your work, observe the lights and darks of colors in your palette. Your sense tells you that yellow has a lighter value than blue. However, if you study your pigments, you'll see that even though you think of yellow as being lighter than blue, cerulean blue is lighter than quinacridone gold—because cerulean blue has white in it, which makes it clearly lighter than many colors. Can you identify other colors in your palette that are exceptions to the "rules" of color and value?

The challenge for every painter is to see color and value both separately and conjointly. In a flat rendering of something, the color may help identify the subject. For example, a red frog may be difficult for our mind to read; however, if the silhouette or form of the frog is exceedingly distinct and graphic, our minds will accept the red of the frog. This is one of the aspects of Post-Impressionist and Expressionist work that makes it so fascinating. How do we translate that quality into our watercolor paintings?

Judy Laliberte
**COPY OF AN EDVARD
MUNCH PAINTING**
Watercolor on paper, 12 × 9" (31 × 23 cm).

Creating this painting helped the student who painted it to see how color can be used expressively. Another good example of how much can be learned through the close study of great art is by copying it—a tradition that great artists themselves have practiced through the ages.

temperature and saturation

Choosing a palette for a painting is often limited to the idea of literal color. By selecting seven colors, from light to dark, you will have a clear value progression in your color scheme to replicate the actual colors of whatever you see in front of you. But for a more imaginative approach, the trick is to override your literal left brain, which wants you to paint the *exact* colors you see. As we discussed in Lesson 4, color is relative. Play with it and offer yourself the chance to make palette choices related to your emotions, rather than choices guided by the actual colors of objects. After all, you may be outdoors painting on a spring day, but despite the sunny weather, you're feeling moody or depressed. Why not choose a deliberately desaturated palette to reflect your feelings, rather than slavishly depicting bright colors in the landscape? Here are some choices for you to explore:

WARM PALETTE Create a painting based mainly on warm tones, yet progressing from light to dark in the value scale. This is a challenge, since warm colors are often inherently light in value.

COOL PALETTE Create a painting based mainly on cool tones, yet progressing from light to dark in the value scale. This is a challenge, since cool colors are often inherently dark in value.

SATURATED COLOR Create a painting with intensely bright colors, disregarding the literal color of the landscape or subject matter; let your eyes focus on value. Create a saturated palette of seven intense tones. Paint the values directly with the colors. You will be doing little or no mixing in this painting, since the color needs to stay saturated and bright.

DESATURATED COLOR Create a painting with six subtle, desaturated colors, including white, again, potentially disregarding the literal color of the landscape or subject matter; let your eyes focus on value. Paint the values directly with the colors. You may be doing more mixing in this painting, since mixing two or more watercolors tends to desaturate them.

EMOTIONAL, EXPRESSIVE COLOR
Seeing the world in less-rendered color allows viewers to explore their own psyches as well. The German Expressionists, who evolved out of the French Post-Impressionist movement, changed the way we see color today. In the early twentieth century, it may have been shocking to see a portrait painted with a green tinge to it. Today, unusual colors are often jarring and discordant, though they can also be strikingly beautiful. I associate this method of painting with what it must be like to play jazz—the usual notes are in different places, yet their combination creates a rhythm. Like jazz, how you "play" the notes affects how we see the color. Depending on the colors you choose for a given painting, you are inviting the viewer to see aspects of how you felt when you created that work. Color conjures emotional feelings in all of us.

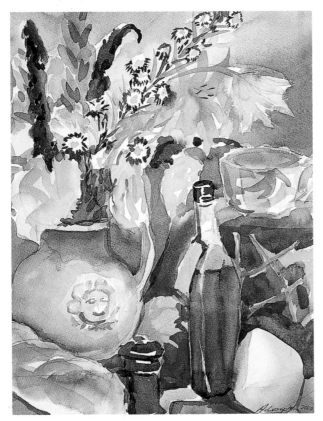

Annette Carroll Compton
SPRING SPREAD
Watercolor on paper, 16 × 12" (41 × 31 cm).

color as value scale

Make your own value/color scale, using my example as a guide. Each row progresses through value, from light to dark. Try making a painting with one of them. Instead of mixing the colors, use them directly, making gestural brushstrokes to create a strong impression. Notice how a less intense, desaturated palette changes the feeling of a subject, versus a clear, saturated range of colors. The colors I used are identified by brand, explained in the footnote.

1. indigo (WN); six values, from lightest to darkest

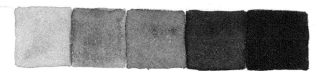

2. aureolin (WN), cadmium orange (WN), permanent rose (DS), Winsor green (WN), French ultramarine (WN), Winsor violet (WN)

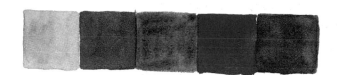

3. Naples yellow (WN), yellow ochre (H), olive green (WN), Indian red (WN), indigo (WN), ivory black (WN)

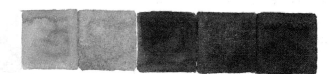

4. cadmium lemon (WN), cadmium orange (S), cadmium red (WN), permanent red (WN), peacock blue (H), royal blue (H)

5. rich green gold (DS), quinacridone burnt orange (DS), permanent sap green (WN), cobalt turquoise (WN), permanent magenta (WN), moonglow (DS)

6. aureolin (WN), quinacridone gold (WN), rose madder genuine (WN), viridian (DS), cobalt blue (DS), cobalt violet (S)

7. new gamboge (WN), cadmium yellow deep (WN), organic vermillion (DS), cerulean blue (WN), Prussian blue (WN), warm sepia (WN)

(WN) WINSOR & NEWTON, (DS) DANIEL SMITH, (H) HOLBEIN, (S) SENNELIER

direct painting

When we use one watercolor pigment "pure," not mixed with another hue, I refer to the process as direct painting. Using paint this way is very effective when you paint emotionally, reacting to your environment or subject matter through choice of color. Your brushstroke is visible, the color pure. Particularly when you paint this way, I recommend that you use the best-quality watercolor pigments, even though they are not as economical as student-grade series.

If you study the work of many experienced watercolorists, you'll see that through years of working, the balance of water and pigment has become second nature to them. Their marks are fresh, not blotted or smudged from fear of making a mistake. Look to their example, and the next time you see what you think is a "mistake" in your work, reconsider. So what if you put an abnormally bright color on your painting? Rather than despairing, paint with that color for a while, reflecting on its *value* rather than its hue. Enjoy having that cadmium red express the middle-light value of everything in your painting, and see what that offers you. See the painting through, rather than abandoning it with one stray mark.

The odd color that you use to express value—whether it is the cerulean blue in the leaves or the cobalt violet in the shadow on the face—will break you out of your confined thought pattern. You may not always paint this way, but the next time you "get into trouble," you may be willing to dare to experiment. The freshness and immediacy of watercolor as a medium makes this kind of play with color the fastest route to building your confidence as a heartfelt, expressive artist.

HEART EXERCISE

painting with unmixed colors

Listen to instrumental music that you enjoy. I like jazz for this exercise, for the music reflects the process. Set up a mirror in which you can see yourself clearly. Choose up to five colors—ones that reflect your feelings. Use these colors unmixed, and paint an expressive self-portrait. Enjoy the process of discovering which colors advance and which recede. How have you chosen to render lights and darks? What emotion is conveyed in your painting? In my example, I used a value scale that includes the liftable pigments: aureolin, rose madder genuine, viridian, cobalt blue, and cobalt violet. I also used staining quinacridone gold as a dark-value yellow to enhance the progression.

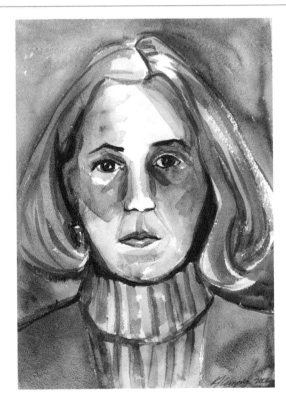

Annette Carroll Compton
SELF-PORTRAIT
Watercolor on paper,
30 × 22" (76 × 56 cm).

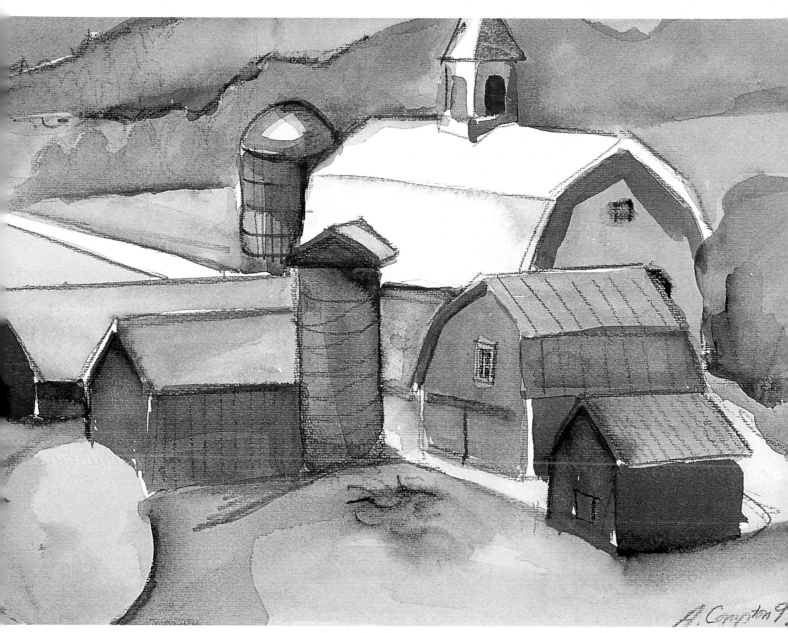

Annette Carroll Compton
THE LEWIS FARM
Watercolor on paper, 12 × 16" (31 × 41 cm).

Here's a stretch: pink barns, turquoise hills! But why not? My heart drew me to those colors for this scene. Use your knowledge of line, form, and value to create realistic images—then paint them in colors that strike a chord with how you feel.

saturated, desaturated palettes

Work from a black-and-white photograph, and assign colors to the values from light to dark. Prepare to paint two versions: one with saturated colors, the other with desaturated. In each, try to create the illusion of three dimensions with the palette you have established. Break down the value into shapes of color. Create clear value progressions with pure pigment from your palette. In my two examples, the palettes are as follows:

SATURATED COLORS *(below left)* aureolin, cadmium orange, cerulean blue, permanent rose, French ultramarine, Winsor violet, and indigo.

DESATURATED COLORS *(below right)* Naples yellow, rich green gold, quinacridone gold and burnt orange, permanent magenta, cobalt turquoise, Winsor violet.

PHOTOGRAPH BY ROBERT GAMBEE

lesson 10 studies

MIND WORK From this lesson's list of "Great Artists to Explore," research the work of the painter whose emotional style—through color, content, and/or technique—appeals to you most. Copy a painting by that artist. The student work on this page is a colorful result of this challenging assignment.

GREAT ARTISTS TO EXPLORE

WHO USE EMOTIONAL COLOR IN EXCEPTIONAL WAYS

Mary Cassatt

André Derain

Raoul Dufy

Paul Gauguin

Tamara de Lempicka

August Macke

Franz Marc

Edvard Munch

Georgia O'Keeffe

Georges Rouault

Georges Seurat

Chaim Soutine

Carol Orgain
COPY OF AUGUST MACKE PAINTING
Watercolor on paper, 7¹/₄ × 6³/₈" (18 × 17 cm).

HEART WORK In early morning, soon after awakening, meditate for five minutes to see how you feel. Then choose a palette that expresses those emotions. With those colors, create a small painting in your sketchbook to record your heart as your day begins. Subject matter doesn't matter here. Your morning painting may be an enigma to viewers, as my examples probably are. The important thing is practicing how to put personal feelings on paper while gaining confidence with your brushstroke and color sense.

MIND-HEART WORK Choose a place that holds an emotional association for you. Depict this place in colors that express those emotions. You may find yourself working in a style similar to the painter you chose in the "Mind Work" assignment—or perhaps you'll use your own unique style. In my example, I replicated the values I saw, but translated them into colors that expressed my feelings for this particular setting.

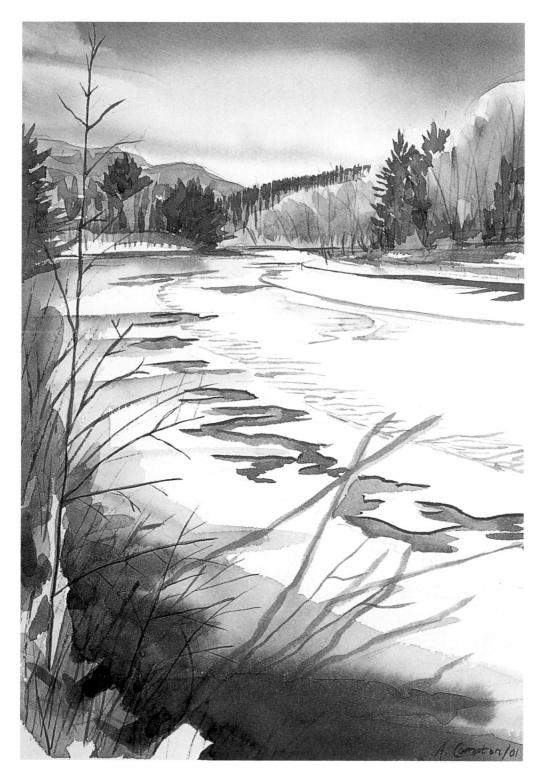

Annette Carroll
Compton
**FROZEN
OTTAUQUEECHEE**
Watercolor on paper,
16 × 12"
(41 × 31 cm).

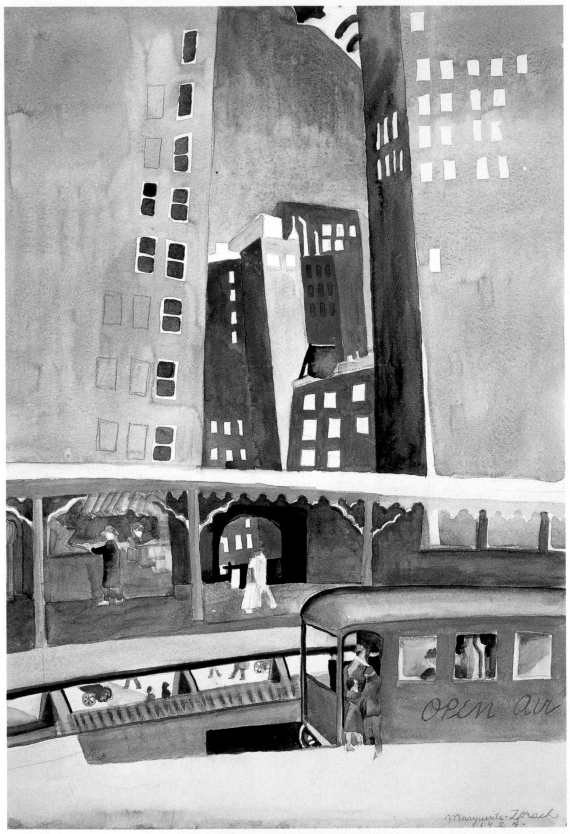

Marguerite Thompson Zorach, American, 1887–1968
SIXTH AVENUE "L," 1924
Watercolor and graphite on heavy wove paper, 22⅛ × 15½" (56 × 39 cm). W.935.1.75
Hood Museum of Art, Dartmouth College, Hanover, New Hampshire; gift of Abby Aldrich Rockefeller.

Patsy Highberg
**DECONSTRUCTION
OF CITRUS FRUITS**
Watercolor on paper,
each 6 × 4" (16 × 10 cm).

Annette Carroll Compton
DECONSTRUCTION OF CITRUS FRUIT
Watercolor on paper, each 4 × 6" (10 × 16 cm).

advance and recede

Hans Hofmann did much to codify the Abstract Expressionist movement. His writings and teachings explore the concept of making space appear three dimensional within the picture plane. As watercolorists, we can become so enamored of the medium that we sacrifice a dynamic illusion of space. We may overwork a painting, trying to get the exactitude of the subject, when instead, we could use some of the principles of abstraction to get at the true essence of the subject.

Take the example of a still life of fruit on a sunlit windowsill. I could paint every berry and draw every line, or I could examine the elements of form and observe how light affects the overall scene. In my painting, I would take into account where white shapes might leap off the page—yet, I might want the shimmer of red berries and gold leaves to stand out. I would consider if some lines are distracting, some details overwhelming. It is my job as an artist to edit the large shapes and small details selectively, to decide what to share with my viewers. These time-honored theories are helpful guidelines in making those decisions:

- Warm colors tend to advance.
- Cool colors tend to recede.
- Saturated, pure colors tend to advance.
- Desaturated, heavily mixed colors tend to recede.
- Textures tend to advance.
- Smooth surfaces tend to recede.

HEART EXERCISE

fast, expressive landscape

Tear one full sheet of watercolor paper into eight equal sections. Collect eight different photos of landscapes that appeal to you. Tape the first sheet to your board and look carefully at the picture for a minute. If it is a place you have visited, recall and enjoy the memory. Put the first photo facedown, set a timer for ten minutes, and begin painting what you remember, using big swashes of color. I think of a landscape as a stage set, with the sky and ground planes going in first, details last. Play with verticals and horizontals to express the energy and character of the place. Don't be concerned with the edges of things or whether the outcome is representational. When the timer goes off, begin the next painting. By the time you've finished the eighth image, your brushstrokes should be looser and freer.

Annette Carroll Compton
**FAST, EXPRESSIVE
SEAFOAM AND ROCKS**
Watercolor on paper,
5 × 6¹/₂" (13 × 17 cm).

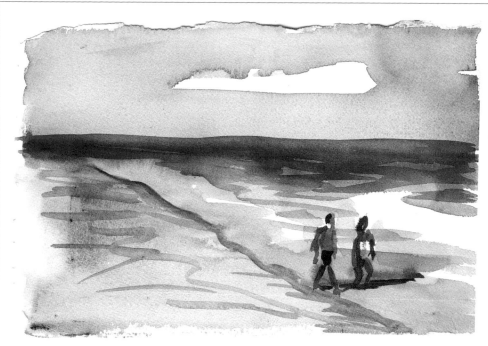

Annette Carroll
Compton
**FAST, EXPRESSIVE
BEACH WALK**
Watercolor on paper,
$5 \times 6^{1}/_{2}$" (13×17 cm).

Annette Carroll Compton
**FAST, EXPRESSIVE
AUTUMN TREE**
Watercolor on paper,
$5 \times 6^{1}/_{2}$" (13×17 cm).

freedom with paint

For many of you, this is a thrilling arena, exploring how the paint itself works on paper. Simply allowing it to tilt and spill is exciting. Finding images within the accident of painting may be a route you may wish to pursue; others may feel uncomfortable here. Often students say, "This is pointless. I'm wasting paint and paper. I need to paint *something.*"

I understand that feeling. The gift in learning more about abstraction is that it allows us to free our literal thinking. I find that the gestural strokes in Willem De Kooning's work and the daring color of a Helen Frankenthaler painting give me permission to release my own inhibitions when it comes to applying paint. The next exercise is designed to help you do that.

abstracting a still life

If you have a realisitc still-life painting of your own creation, use it for this exercise. If not, look through art books or other sources and choose a traditional still-life painting for you to interpret abstractly. You might begin with small graphite sketches to stimulate ideas for placing altered shapes, distorted lines, changed values, and other abstractions of objects in the still life. When you begin to paint, this is the time to let your brush and color be free. Explore texture through dry-brush techniques and the flow of color through wet-on-wet. Be inspired by the painting, but break away from the obvious contours of things. Let color, value, shape, form, and line exist without having them need to describe reality.

Jane Elliott
**REALISTIC
STILL LIFE OF FRUIT
AND ABSTRACTION**
Watercolor on paper,
each 12 × 16"
(31 × 41 cm).

128

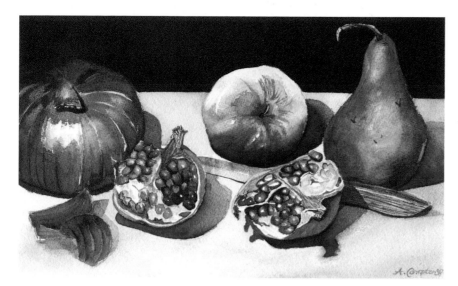

Annette Carroll Compton

LEFT: **REALISTIC
STILL LIFE**
Watercolor on paper,
9 × 16" (23 × 41 cm).

CENTER: **SKETCHES
ABSTRACTED**
Graphite on paper,
each 4¼ × 5¾" (11 × 14 cm).

BOTTOM: **ABSTRACTED
STILL LIFE**
Watercolor on paper,
12 × 16" (31 × 41 cm).

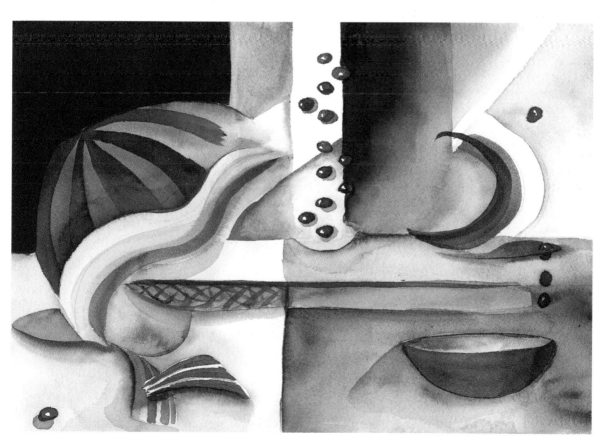

lesson 11 studies

GREAT ARTISTS TO EXPLORE

WHO USE ABSTRACTION IN EXCEPTIONAL WAYS

Milton Avery

Willem De Kooning

Arthur Dove

Helen Frankenthaler

Hans Hofmann

Morris Louis

Joan Mitchell

Pablo Picasso

Jackson Pollock

Marguerite Zorach

MIND WORK This is a variation on an earlier exercise done with paint; use pencil this time. Choose a piece of fruit that will last a week (or have a backup). The first day, draw it realistically; the second day, find one thing about it to abstract; the third, another, and so forth. By the seventh day, you should have a totally abstracted image of the fruit, yet one that still has its "essence." In the example shown, this student's final abstraction took a whimsical turn, as her deconstruction of an orange has sections of it flying off into space, adding a surreal narrative to her drawing.

Carol Orgain
DECONSTRUCTION OF FRUIT
Graphite on paper,
6 × 8" (16 × 20 cm).

MIND-HEART WORK Take a situation or a relationship in your life and write about it for fifteen minutes. Then see if you can create a painting that reflects your words. Perhaps create an unusual texture on your painting by experimenting with grains of salt or drops of alcohol to diffuse the pigment in interesting ways. Have the image evoke the feelings and complexity of the relationship or situation about which you have written. Notice what happens as you layer and glaze some of the colors.

Carol Orgain
EMOTIONAL SITUATION
Watercolor on paper,
12 × 16" (31 × 41 cm).

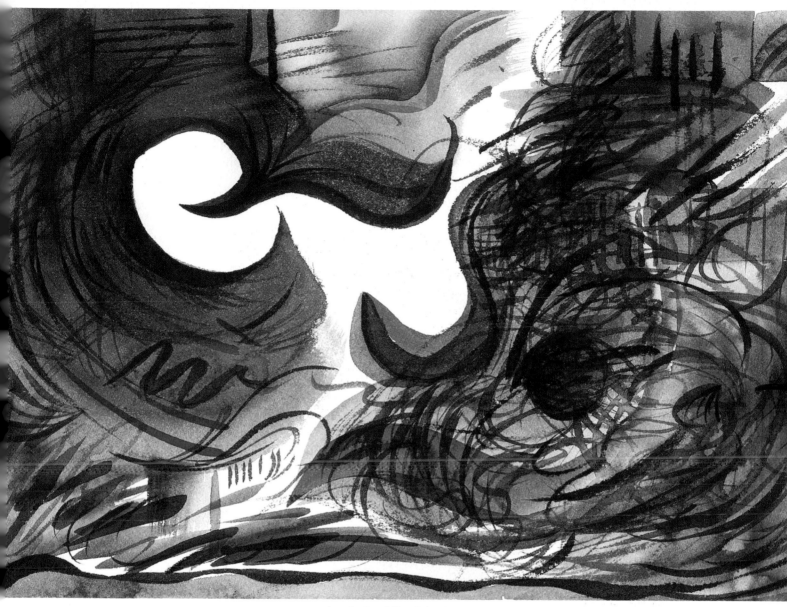

Annette Carroll Compton
RELATIONSHIP TO KRB
Watercolor on paper, 12 × 16" (31 × 41 cm)

Abstract Expressionism often uses bold, forceful brushstrokes, fluid paint, and vibrant colors to convey the artist's emotional reaction to a personal situation or relationship.

Lawrence Goldsmith
DARK OF THE NIGHT
Watercolor on paper, 24 × 18" (61 × 46 cm).
Collection of Linda Goldsmith.

finding your own voice

Nonobjective painting allows you to lose conscious knowledge of your training and to experience the joy of play. It differs from abstract painting in that most nonobjective work starts and ends with no reality in mind at all—no landscape, no still life, no figures, no faces. Your mind is quiet while your heart guides you to pick up your paintbrush for nonobjective work. You feel confident with the techniques you have mastered and trust the process of your own personal expression. The painting informs you of your next move and tells you when it is complete. Your judgment is silenced by the sheer joy of mark-making. You become childlike, yet courageous.

INTEGRATING THE MIND AND HEART

While nonobjective painting may not be the way you want to work always as an artist, knowing how to get to that free a place is bound to help you find your own voice, your own style. Toward that end, the goal of this lesson is to have you access areas of both your mind and heart to improve your artistic expression. To quote Willem De Kooning's thought on knowing ourselves as artists: "The attitude that nature is chaotic and that the artist puts order into it is a very absurd point of view, I think. All that we can hope for is to put some order into ourselves."

You may be disquieted by some of the unstructured, playful work or you may be frustrated by the skill required for some of the more analytical exercises. This discomfort is good, because it tells us about ourselves. You have gotten to this lesson, and for that you can be commended! Even if you have practiced only one exercise from this book so far, you have opened your mind to a different possibility in your work as an artist. If you have accomplished all of the exercises,

no doubt you have a large body of work and much to review. Being a creative artist involves constant mutation, constant evolution. The world around us changes every second, so as artists, we must become flexible and responsive. Knowing yourself can help you respond better to the changing environment.

Annette Carroll Compton
SPLASH
Watercolor on paper, 16 × 12" (41 × 31 cm).

Creating nonobjective art can be an experience in responding to the materials you use.

exploring techniques of expression

Discover the ways watercolor responds to different techniques. The six ideas that follow can be combined in one painting, or you might want to create separate paintings for each technique, as shown in my examples.

Tape a sheet of watercolor paper to a board. Wet the paper, then mix a color in a small paper cup. Pour the paint on the wet surface and begin to tilt and spill the color. Explore what the color does. Bring a second color into it. Now, while it is still wet, use drops of rubbing alcohol to affect the color and produce bubblelike forms.

Perhaps add more sedimentary color in a given place. Now take some crinkled-up plastic wrap and move it around on the wet paint, going in different directions, making mosaiclike patterns. Let the whole piece dry. Now you may want to add secondary layers. Play. Explore. Trust. Experiment with iridescent paints. Try etching with the back of a brush handle to produce an abraded well in which pigment rests, creating a darker line in your painting. Take some of these techniques into your future work. Trust is what builds confidence in a painter.

SALT *Place on semi-wet sedimentary colors. Lay in the color fairly thickly so the salt has pigment to gather into the starlike spots it leaves.*

RUBBING ALCOHOL *Apply with an eyedropper onto any wet pigment to create these interesting, bubblelike forms. Alcohol hastens the drying process as it hits the color.*

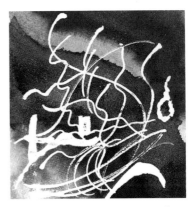

MASKING FLUID *Once it is dry, you can paint with abandon, being sure that what you have masked will stay white until you remove the dried masking fluid.*

PLASTIC WRAP *Crinkled and moved around on wet paint, it produces mosaiclike effects. Weight the wrap with a book while the painting dries. Pigment will dry darker in places, lighter in others.*

IRIDESCENT PAINTS *When dry, they become a bit opaque. Mixed with transparent watercolors, they can desaturate rather than brighten the hue. I usually apply them last, so they sit on top of other colors.*

ETCHING *Using a brush handle creates an abraded well in which pigment rests, producing a darker line in the painting. Etching is also useful in realistic work, as in depicting grasses in landscape.*

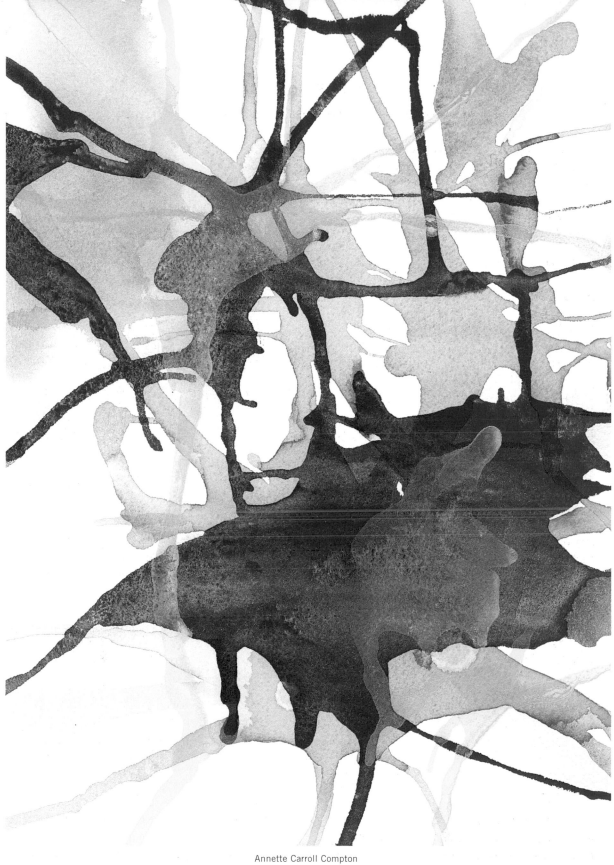

Annette Carroll Compton
POURING PAINT
Watercolor on paper, 16 × 12" (41 × 31 cm).

Becoming facile with many techniques is a challenge. New products keep coming to the market that intrigue and excite. Spend time with them and evaluate how they can be useful to you in nonobjective, abstract, and realistic work.

neutralize judgment

In my classes and workshops, we often have critiques. I ask students to present their work without editorial comment, which is more challenging than you would think. Something about presenting our work makes us want to defend it, degrade it, or explain it. The reason I ask artists to remain silent is that this is visual art. The audience responds visually and often reacts immediately. Gasps of approving *ahs* are rarely heard after an artist has had a chance to explain that "I did the work in a hurry and it isn't very good. I didn't draw the perspective properly." The minute we hear all that, we are looking for evidence of these statements rather than judging the work through our own filters. Can you imagine going into a gallery and before we saw each painting, having to listen to a diatribe from the artists about how they wished their creations were better?

Of course, we often want our work to be better, yet "better" describes a value judgment based on a fantasy of what we think our work is supposed to be. Making work is of the moment. The humidity of the afternoon, the barometric pressure, or one's hormonal balance can throw any sensitive being into a state. But in spite of all those variables, an artist is making work in that very moment. Its uniqueness is what makes it precious, an individual creation. Combined with technical confidence, it can become a work of art.

Judgment often makes us look at our work as "good" or "bad," but consider your work in the context of how you work and what you like to do. This can change a strong judgment to a realistic assessment of where you want to go with your work and how you want to get there. The process of being an artist is not a straight trajectory upward to the stratosphere of success. It is a sloping spiral, and as you evolve, after every failure you will always see some progress. The trick is to avoid being discouraged by the seeming failures and to continue making work without judgment. Even the greatest artists feel failure.

To neutralize some of the judgment in your mind, work with other artists in a group-painting exercise. Also, when you complete the self-evaluation that's coming up in a few pages, that will help you to understand more about your work and, I hope, approach it with a nonjudgmental and open mind.

Annette Carroll Compton
UNTITLED
Watercolor on paper,
12 × 16" (31 × 41 cm).

If you approach nonobjective painting nonjudgmentally, you may discover wonderful new color combinations, brushstrokes, and rhythms for your watercolor work.

group painting

Gather a group of artist friends. Put a large sheet of watercolor paper on a board, set on an easel. Ask someone to go to the easel and paint for a few minutes. The group observes the work as it progresses. A second person goes to the easel and paints on the same sheet. As another person is moved to participate, the current artist relinquishes the brush and hands it to that colleague.

Establish that it is all right to interrupt the painter who is working, as long as everyone gets a fair chance at the easel at some point. Let each person's voice be seen and heard, but don't be afraid to paint over color that is already there. You and the others should notice how you feel while doing this exercise. Evaluate you own ability to let go of control.

what do you know about your work?

Here's an opportunity to use your mind to evaluate where you are with your work, after having been exposed to the ideas and exercises presented in this book. This self-evaluation will help with your awareness of where your artistic instincts lie and how you usually approach drawing and painting. Remaining open to new influences will keep you growing as an artist, and perhaps, if you review these questions again in a few months, the answers you check off will be different.

MARKS What type of marks do you respond to most? Which do you make repeatedly, perhaps while doodling on the telephone? If you're asked to mark a paper with a random mark, which would it be?
- ❏ Gestural, loose, spontaneous, emotional, subjective, soft
- ❏ Cool, linear, ruled, objective
- ❏ Linear—the contour is critical to you
- ❏ Automatic marks from your subconscious
- ❏ Brushmarks more than linear marks
- ❏ Undefined drips, splashes, liquidy runs

SHAPES If you were a shape or a combination of shapes, what would you be? Which shapes are you drawn to in furniture, clothing, food, your environment?
- ❏ Geometric—squares, rectangles, triangles, circles
- ❏ Biomorphic forms related to growing forms
- ❏ Extreme three-dimensional volumes in space—think fantasy or computer art
- ❏ Abstract shapes that hold meaning for you
- ❏ Free-floating or accidental shapes from masses of paint
- ❏ Regulated patterns of shape in a repeated pattern

LINE What type of line (continuous mark) do you make when you scribble? What type of line do you make repeatedly?
- ❏ Gestural, curvilinear

- ❏ Geometric, rectilinear
- ❏ Rendering of realistic forms
- ❏ A series of abstract shapes
- ❏ Line to create form—crosshatching to create value
- ❏ Spontaneous, based on what you see and how it strikes you

VALUE What appeals to you in terms of dark and light relationships? How do you use value in your own composition?
- ❏ High contrast—dramatic darks, bright lights, few midtones
- ❏ Medium contrast—midday light, emphasis on midtones
- ❏ Low contrast—flat color, no value shifts
- ❏ Value to create space—lights retreating, darks advancing
- ❏ Just enough to make a form three dimensional
- ❏ To establish mood with frontlighting or back-lighting
- ❏ Surreal shadows, odd lighting from unexpected sources

SPACE What type of spatial concept best describes what you like to create in your work?
- ❏ Flat, no frills—graphic shapes of value and color only
- ❏ Shallow space—defined by a definite backdrop as in many still lifes
- ❏ Deep, realistic use of space through perspective
- ❏ Dramatic, surreal three-dimensional vistas as in computer animation
- ❏ Abstract, intuitive space—subjects advance and recede but may be surreal

COLOR How do you use color in your work now?
- ❏ Descriptively, realistically—subjects from material world, local color

- Impressionistic color, away from actual color to create space, feeling
- Expressive, psychological—color associated with emotion
- Intellectual, scientific—fascinated by application of color theory
- Heavily mixed tints, tones, shades—emphasis on value rather than pure color
- Pure color, saturated hues fresh from tubes
- Care little about color—prefer black and white

SIZE Which surfaces/supports/work space do you prefer?
- Notecard or miniature paintings
- Intimate work space, small desk area
- Easel painting—standing, working at arm's length
- Extra-large watercolor paper, large studio
- Wall-size paintings, murals, large studio

SUBJECT What do you like to paint? What holds meaning for you?
- Still-life objects arranged for shape, interesting groups
- Landscape—location or from photographs
- Figure—within an environment, relating to it
- Formal portraits
- History painting—depicting real events
- Narrative storytelling—book or other illustration
- Wildlife images—location or from photographs
- Political statements or social satire
- Personal, diaristic paintings—the artist as subject
- Technical drawing for engineering or design purposes
- Abstract Expressionism—emotional life of artist through abstract shapes
- Nonobjective art—materials are the subject, using varied techniques

CONTENT If art is a visual language, what is it that you want to communicate to your audience?
- Personal vision—artist's sensibility expressed with line, form, value, color
- Symbolic—human nature explored, universal archtypes expressed, shared
- Abstract—line, form, value, color used to provoke, delight

- Realism—to enlighten, inform, impress
- Narrative—telling a story through pictures
- Series—works linked through content, but light, color, value may change

AUDIENCE For whom do you make your work?
- Yourself, enjoying the process only, caring little about the outcome
- Children
- Adults
- Art buyers, galleries, art world in general
- People from cultures other than your own
- Posterity—you want to make a record of your own culture and times
- All of the above
- None of above—audience doesn't matter

STYLE Think about your personal world. How is it arranged? You might imagine your clothes closet or your refrigerator as a reference point.
- Ordered, prioritized, neat
- Random order, having a personal system but unknown to others
- Uninterested in order—spontaneous, immediate
- Chaotic, deliberately random, enjoying natural sense of chance

PROCESS What is your process of making art now?
- Needing order and discipline to create—neat, pristine, sterile
- Moderate order, with several tasks going at once
- Deadline-oriented, working only with a goal
- Free-floating, creative, as the spirit moves
- Calculated worker—aggressive, need to produce a volume of work
- Enthusiastic frenzy—music blaring, an aerobic exercise
- Silent meditation—a quiet, peaceful time to yourself

These final questions to ask yourself have no multiple-choice responses: Does your art reflect who you know yourself to be? Are you at peace with your marks as an artist—or are there things you still want to change? Are you dissatisfed with what you produce in relation to who you believe you are?

What do you think you need to change about your process to achieve what you want in your work?

WHAT NOW?

As you come to the end of our last lesson, you may be ready to study more technique. Or you may feel your need to paint more to flex your expressive muscles. The exercises in this book can be cyclical and practiced indefinitely. If you continue to explore them, I believe you will come to know yourself and your work better. More questions—rather than fewer—may be revealed. Drawing and painting are lifetime pursuits—which is what makes art so fascinating and rewarding.

Lisa Theurer
NONOBJECTIVE PAINTING
Watercolor on paper,
16 × 12"
(41 × 31 cm).

Sheryl Trainor
NONOBJECTIVE, AFTER MORRIS LOUIS
Watercolor on paper,
16 × 12"
(41 × 31 cm).

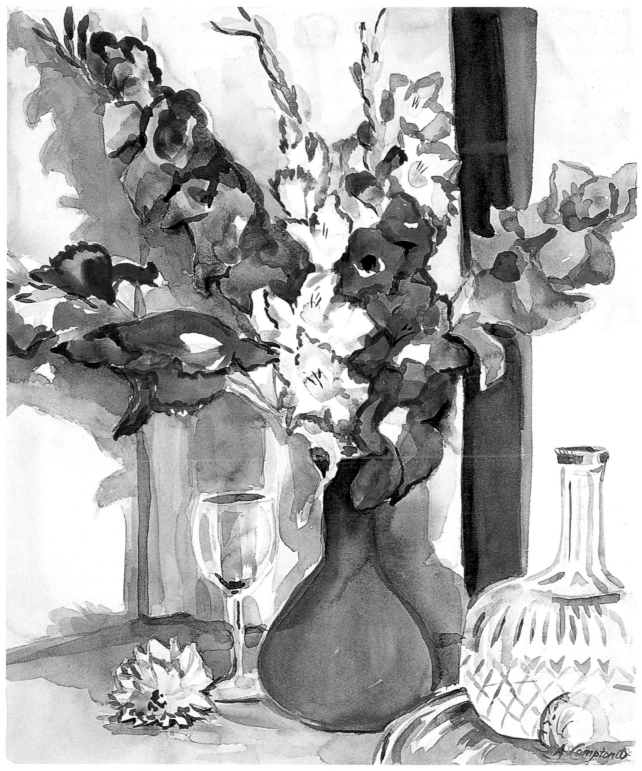

Annette Carroll Compton
THAYER'S GLADIOLUS
Watercolor on paper, 30 × 24" (76 × 61 cm).

Even in a realistic interpretation of a subject, the same freedom found in nonobjective work can help create a passionate response. Trust that your mind has learned new techniques, while you follow your heart.

afterword

I believe that art is connected to something larger than our own small selves. As artists, we have a way to use our talent as a deeply satisfying form of communication with others. Figure out ways that you can share your gift of being able to draw and paint. Offer to teach young people. Work with seniors. Give away your paintings. Cut up your rejected marks and send them as postcards. Offer yourself generously. Ideas for new works keep flowing if you let go of your judgment and criticism and freely give what you have.

RETURNING THE GIFT

I was asked to do a show for a local hospital to commemorate National Breast Cancer Awareness Month. I started looking through my work, thinking nothing would really be appropriate. I began doing research, thinking about depicting possible cures or causes, but

nothing seemed to inspire. Instead, I asked the hospital if I would be able to visit the support group, just to listen and perhaps to sketch. I took my watercolors.

The first night, the women had all sorts of information to share with me, but what I noticed more, was the interaction of these women among themselves. I asked if I could draw and paint. They agreed, and invited me to come back again. For eight months, I went once a week to record these women in various stages of recovery from cancer. Then I put the paintings I had done up on my studio wall, and an artist friend came in and was mesmerized by the thirty or forty images. He asked, "What are these?" and I said, "Oh, just preliminary sketches for some paintings." He convinced me that they weren't preliminary—that they were final paintings because they were fresh, direct, and expressive. But I was uncomfortable

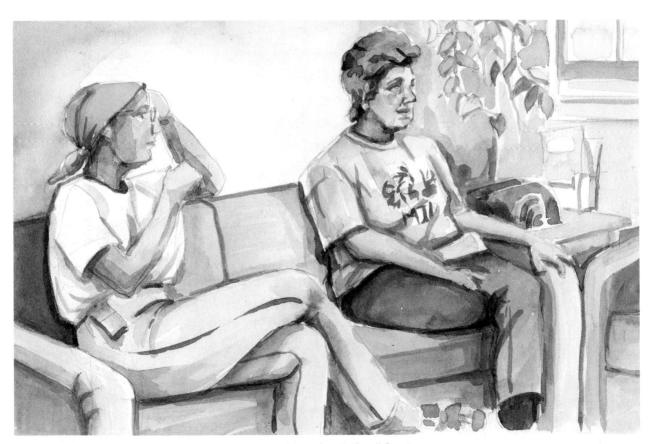

ABOVE AND OPPOSITE: Annette Carroll Compton
BREAST CANCER SUPPORT GROUP SERIES
Watercolor on paper, each 12 × 16" (31 × 41 cm).

showing my process in my work. I wanted more "finish" to "get it right." He persuaded me to exhibit the paintings as they were, and the show was such a great success that it traveled to three other hospitals and galleries.

SHARING OPPORTUNITIES

Currently, there are groups like the Art Exchange in Boston sprouting up: a nonprofit organization that will take your work and show it in places that may not have funds or access to art. Perhaps your community has a similar program that would welcome your participation.

An artist friend of mine lives in a RV and travels around the country. After years of being a graphic designer, she and her husband live on the road now. She paints nearly every day. Of course, there is no room for her work to be stored in the RV, but every year she comes back to Vermont to visit, frames her work, and hangs it at a local deli. Some of her paintings sell, but many she gives to family and friends. The next year, she comes back with a whole new crop of paintings.

Limitless and abundant is how I think of my ability to make work. There is really nothing else that provides such constant richness as making art. So besides the satisfaction of knowing yourself better, you now have much to share with the world. May you give freely, knowing your expression is unique, yet abundant. Enjoy the ceaseless flow.

index